ALSO BY SUSAN SOMMERS
Beauty After 40: How to Put Time on Your Side
How to Be Cellulite Free Forever

French Chic

French Chic

HOW TO DRESS LIKE A FRENCHWOMAN

SUSAN SOMMERS

PHOTOGRAPHS BY ROXANNE LOWIT
ILLUSTRATIONS BY MARY ANN STANIC

VILLARD BOOKS
New York 1988

Library of Congress Cataloging-in-Publication Data
Sommers, Susan.
 French chic.

 1. Clothing and dress. 2. Fashion—United States.
3. Fashion—France. I. Title.
TT507.S686 1988 646'.34 87-40579
ISBN 0-394-54704-7

Manufactured in the United States of America
9 8 7 6 5 4 3

FOR MY FATHER, WITH LOVING MEMORIES

CONTENTS

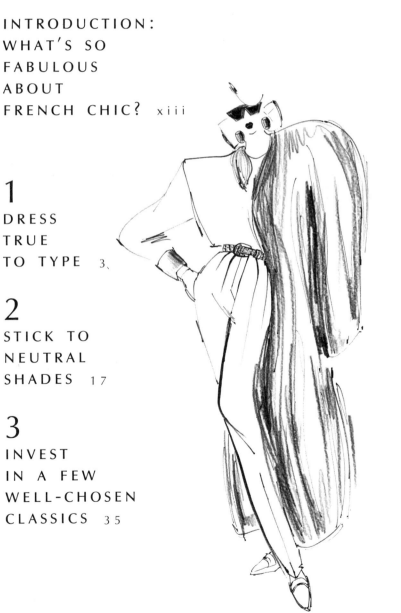

ACKNOWLEDGMENTS

"MILLE MERCIS" to Carla Glasser for her wise ideas and outstanding organizational ability, Roxanne Lowit for her patience, unfailing support and wonderful photographs, Andy Port for her very unique vision, Keith Trumbo for his encouragement, enthusiasm and terrific photographs and my sister Louise Sommers for ongoing legal advice.

Special thanks as well to photographers Mark Bugszester and Sammy Georges, both based in Paris, for pictures that likewise captured the essence of French style; to my illustrator Mary Ann Stanic and my editor Diane Reverand.

I was really sustained by the support and belief in this book by so many people, not only my family and friends, but acquaintances and even complete strangers, both here and in France, who took time from their busy schedules to be interviewed or to set up interviews. My deepest appreciation to them and to all the people who allowed their pictures to be taken. I could never have accomplished this book without their cooperation.

INTRODUCTION

WHAT'S SO FABULOUS ABOUT FRENCH CHIC?

FRENCH women have a reputation for chic, with good reason. They look sensational! They look elegant and original, whether their personal style is traditional, trendy or somewhere in between. There's a certain mystique that's grown about French chic, because it is so indefinable, so inventive and so sought after.

As both a fashion editor/journalist who helps others look their best, and a style-conscious woman who wants her own look to be wonderful, I've spent years being alternately delighted, amazed and beguiled by the French approach. While it's true that different customs, attitudes and life-style promote different charms, French women have something special. They're feminine, sure of themselves, and seem to delight in breaking all the fashion rules, yet making it all work. They have the fashion savvy capable of saving an oh-so-refined suit from utter boredom with

the addition of an impertinent accessory, or of keeping a sassy, street-smart ensemble from looking absurd by tying on a classic Hermès scarf. And they have the fashion confidence to convince you that they're beautiful, even when they're not.

Although it seems spontaneous, French chic actually involves a certain amount of strategy—strategy that I've learned to apply to my wardrobe and that you can too, and so easily. In the following pages, you'll find French translated into American chic, made wearable for your life, your work, your style, from assembling a basic wardrobe to adding the extras and accents, including advice about color, fabric and patterns. You'll meet and greet Frenchwomen on the streets, in their homes and offices and learn how they build their wardrobes, spend their money and select accessories, lingerie, even perfume to add to their allure. You'll rummage through fashion boutiques and flea markets for inspiration, hear tips from top French designers on how to make fashion fun and how the very contradictions in French dress make good fashion sense; you'll see the hair and makeup looks that Parisian beauty experts create for their clients and that you can re-create in seconds.

French Chic explores every aspect of the French fashion attitude and aproach to style, so you'll be able to pull together—and pull off—a succession of fabulous looks with wit, verve, versatility . . . and nerve!

French
Chic

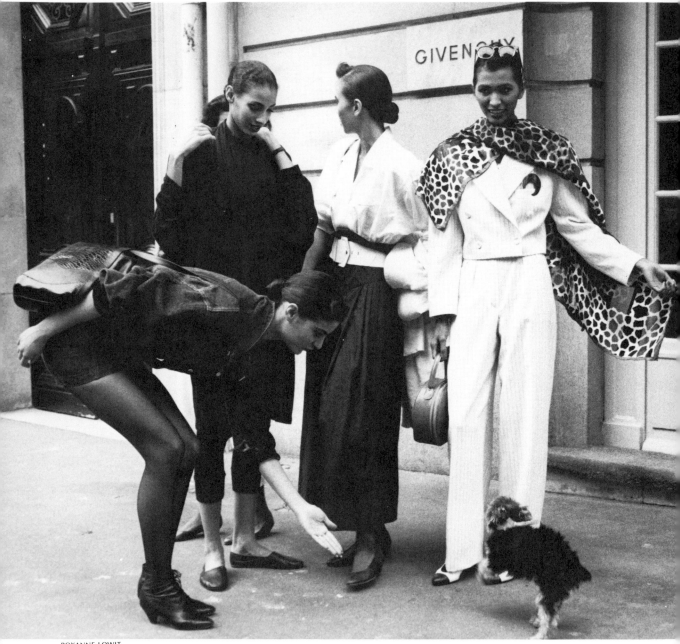

ROXANNE LOWIT

I

DRESS TRUE TO TYPE

While their styles, skirts and trouser lengths vary, these four women share that famous, fabulous French chic.

STROLL along the streets of Paris and you think you've stumbled on an outdoor fashion show. Almost every woman you see has put herself together in a snappy, sexy, alluring way, with an original little fillip that sets her apart. Of course, this city, with its plethora of designers, dressmakers and press devoted to fashion, with its staggering amount of appealing merchandise prominently displayed in shop windows, offers such a high degree of freedom of fashion choice and diversity that at first you may not notice any overall trends. After some time though, you'll see certain basic similarities in dress that for the sake of simplification may be classified into six broad categories: Continental Preppie, Jet-Set Sophisticate, Neo-Classic, Femme Fatale, Trendy and Aristocrat.

The choice of fashion type is very deliberate. Frenchwomen do not allow themselves simply to fall into a fashion. They *select* the image they want to project and dress for it. And they tend to basically remain true to it for all occasions, for all time. But while fashion types exhibit their own distinct characteristics, there is often an intentional overlap, since the French delight in going against the rules on a whim. Actually part of the charm of their chic is the ability to change completely for the occasion. Therefore, no one is ever totally surprised when a strict cashmere-and-pearls girl goes all out one evening in revealing black leather and lace—or vice versa.

Even though these fashion types vary, and the clothes within each category change with the trends and times, they still have a common core: every chic Frenchwoman usually begins with the same basic wardrobe—fully explained in Chapter 3— that she personalizes through cut, color and fabric, as well as through the ways she wears, pairs, adds to and accents it.

So follow their lead. After all, six million chic French-women can't be wrong! Use the following breakdown to determine your fashion type and how you can incorporate some of its key elements in your look, too:

FRENCH FASHION TYPE: CONTINENTAL PREPPIE

CHARACTERISTICS: This style looks as if it was inspired by Ralph Lauren. Any given ensemble usually contains a few American or American-looking elements: a polo shirt, pleated skirt, baseball jacket, western gear. Clean, collegiate and usually conservative, the Continental Preppie is often a little more in the fashion mainstream than her U.S. counterpart, particularly when it comes to mixing patterns.

SHOES/HOSIERY: Ribbed wool or sheer flesh-colored pantyhose, argyle high socks; ballerina flats, penny loafers, cowboy boots.

JEWELRY/ACCESSORIES: Pearl or diamond stud earrings, or small, slim gold hoops; short strand of pearls, short gold chains worn a few at a time; Cartier triple bangle bracelet.

HANDBAGS: Oversized schoolbag in leather or a leather/canvas mix; a backpack; an Hermès shoulder bag with H clasp; a small square leather shoulder bag slung across the chest.

COLORS: All the neutrals—black, white, gray, navy, burgundy, beige, hunter green—plus baby pales: pink, lemon, blue.

PERFUMES: A light, fresh, green or citrus scent, like Vetiver by Guerlain, Eau Sauvage by Christian Dior, which are worn by men and women alike in France; Chanel 19 or Chanel's Christalle.

FAVORITE DESIGNERS: Agnès b, Kenzo (but only his basics), Givenchy (for the older, elegant Preppie who can afford it).

ROXANNE LOWIT

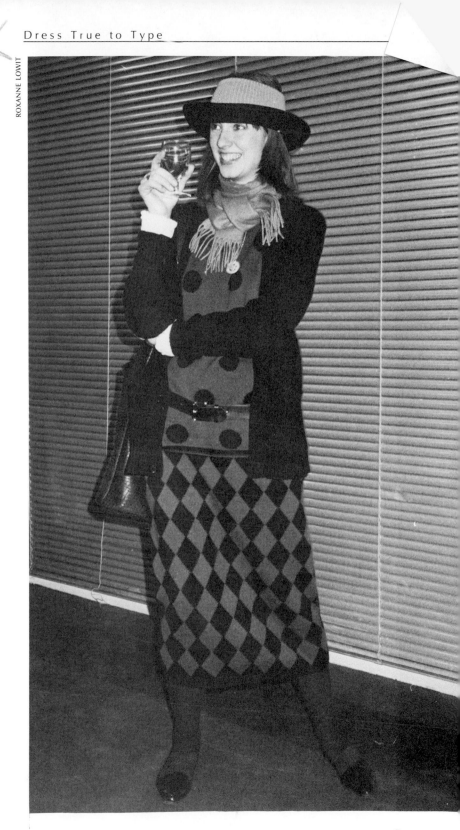

A typical Continental Preppie vaguely resembles a Radcliffe student. She is often smartly layered, and brave about mixing patterns. The polka-dot vest is worn over a solid-color sweater, then under a cardigan, all over a long, slim, patterned skirt. Extra touches include the classic belt worn low on the hips, flat shoes, a man's hat and a wrapped and tied muffler.

FRENCH FASHION TYPE: JET-SET SOPHISTICATE

CHARACTERISTICS: The Jet-Set Sophisticate typifies the high style France is famous for: discreet yet dramatic, tasteful yet understated—and moneyed. Picture a marvelously groomed woman in a meticulously tailored, sober but somehow sexy suit that looks straight out of a renowned designer's ready-to-wear collection. Her roots are Parisian, but she could be at home in any of the world's big cities.

SHOES/HOSIERY: Sheer, dark stockings; high-heeled pumps in black or a shade that perfectly matches the outfit.

JEWELRY/ACCESSORIES: "Real" antique or art deco pins, bracelets and earrings; a gold Cartier "Love" bracelet and Cartier or Bulgari watch; short gold and jewel chain necklaces; sapphire, diamond or ruby and gold earrings. Dramatic, designer costume jewelry, usually worn at night and often mixed with authentic jewels. A cashmere or print shawl thrown over the shoulder of a suit.

HANDBAGS: Quilted Chanel chain-handled bag; Hermès shoulder bag; small leather or suede shoulder bag.

COLORS: Often black and white, plus the offbeat brights a favorite designer is using that season. Perennials include fuschia, chrome yellow, cobalt blue, purple.

PERFUMES: Ysatis by Givenchy; Fracas by Robert Piguet.

FAVORITE DESIGNERS: Yves Saint Laurent, Emanuel Ungaro.

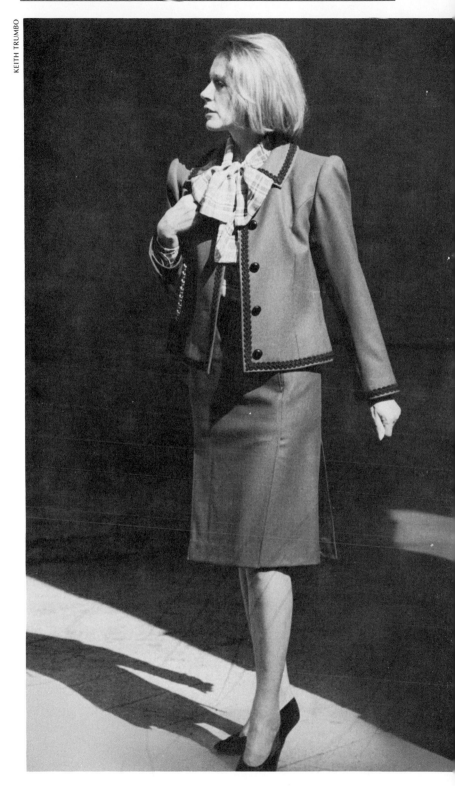

KEITH TRUMBO

A typical Sophisticate: the chic
Saint Laurent suit and pretty
bowed blouse say it all. Except for
an expensive bag and shoes, plus a
barely visible watch, the look is
underaccessorized.

FRENCH FASHION TYPE: NEO-CLASSIC

CHARACTERISTICS: A timeless, pretty style built around the word "little," this look includes spare little dresses, feminine little sweaters and skirts and smart little suits. While the lines are classic, the colors, fabrics and close fit are very current. What really distances this type from its twenties' origins are whimsical accents and accessories.

SHOES/HOSIERY: Sheer stockings; dark pumps or Chanel-style pumps or slingbacks.

JEWELRY/ACCESSORIES: An oversized pin; a silk or leather flower; ropes of gold chains and/or pearls; wide cuff bracelets; big button earrings; chain belts, rhinestone touches and logos.

HANDBAGS: Quilted leather shoulder bag with a chain handle; envelope clutch; oversized quilted or smooth leather tote bag.

COLORS: Ivory, black, navy, red, pale pink and gray.

PERFUMES: Chanel #5; Calèche by Hermès; Diorissimo by Dior.

FAVORITE DESIGNERS: Sonia Rykiel, Chanel.

ROXANNE LOWIT

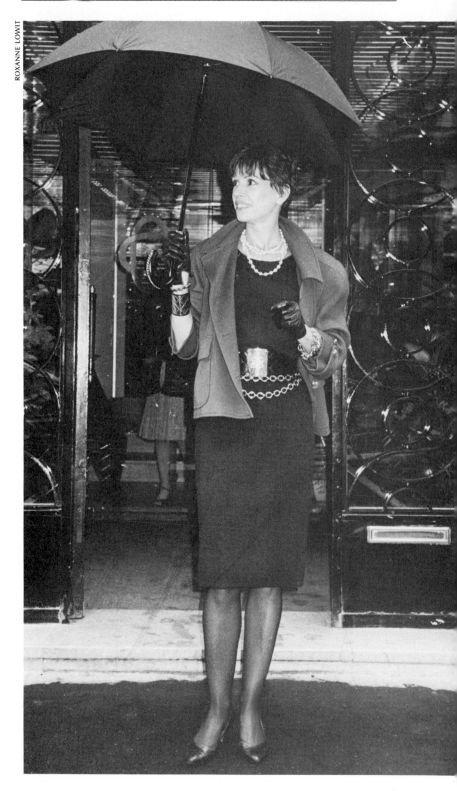

Chanel from head to toe. The
pieces are simple, spare and basic
. . . the accessories provide the
spark.

FRENCH FASHION TYPE: FEMME FATALE

CHARACTERISTICS: For those who really like to be noticed, this is a style that leaves little to the imagination. It is sexy, suggestive and sometimes even tarty. Clothes usually cling to the body like a second skin, although they may not necessarily expose a lot of flesh. When skirts are not short, they are often slit; leather and animal prints are *de rigueur*.

SHOES/HOSIERY: Black lace or fishnet stockings; sheer dark stockings with back seams; black high-heeled pumps or low boots.

JEWELRY/ACCESSORIES: Dark glasses, especially at night; short or long leather gloves; wide leather or cinch belts; dangling or oversized hoop earrings; multiple bracelets.

HANDBAGS: A big clutch; a small shoulder bag on a thin strap, a wrist bag.

COLORS: Black, of course; metallics.

PERFUMES: Opium by Yves Saint Laurent; Poison by Christian Dior; Shalimar by Guerlain.

FAVORITE DESIGNERS: Azzedine Alaïa, Thierry Mugler, Vicky Tiel.

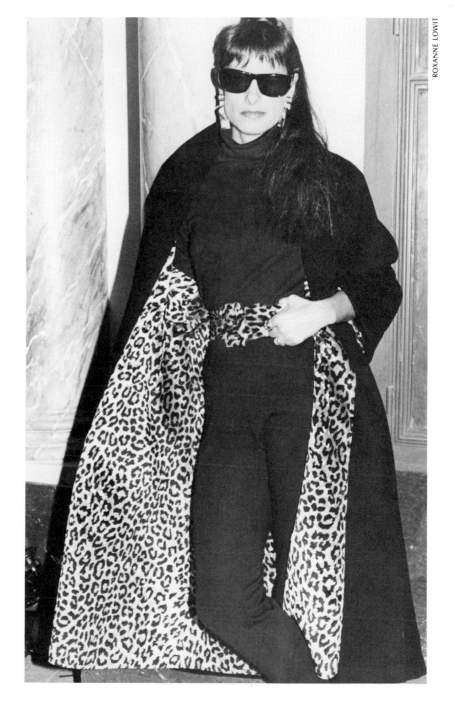

ROXANNE LOWIT

Typical of the Femme Fatale style: body-hugging black pants and top, accented with a leopard-skin print. Note the long earrings and dark glasses, which add to the air of mystery.

FRENCH FASHION TYPE: TRENDY

CHARACTERISTICS: There is no danger in overdoing it, because anything goes with this fast-changing style. It is always original, and can be outrageously fun or funky or just the opposite, depending upon what is hot at any given moment. Often avant-garde, trendies usually influence designers, instead of the other way around. This is quintessential "street" fashion—the most extreme of the six types—and can be found at all the action spots. Even though it is vanguard fashion, it still flatters the wearer. French women never follow fashion blindly—they know what works best for them. Trendy women are usually young or young-at-heart.

SHOES/HOSIERY: Expect the unexpected: there are no constants, since what is in today may not be tomorrow, and this look is often one step ahead of everyone else. The best way for you to keep up is to skim through French fashion magazines, particularly those aimed at teens. Paris trends start young.

JEWELRY/ACCESSORIES: Sunglasses are always part of the package, often more essential than any other accessory. Interesting watches, usually with oversize faces, are also musts, but anything original and out of the ordinary is sported. As far as size, shape and quantity of the jewelry, check the latest fashion magazine for an up-to-the-minute report.

HANDBAGS: As establishment as it may sound, the bags of choice are liable to be classic Chanel or Hermès.

COLORS: While the other colors consistently change, black and white stay trendy constants.

PERFUMES: L'Air du Temps by Nina Ricci, Habanita by Molinard or any other oldie but goodie, especially if it was the perfume her mother wore. Because as original as she may be in her dress, the trendy Frenchwoman still finds some habits hard to break.

FAVORITE DESIGNERS: Claude Montana, Jean-Paul Gaultier, Christian Lacroix.

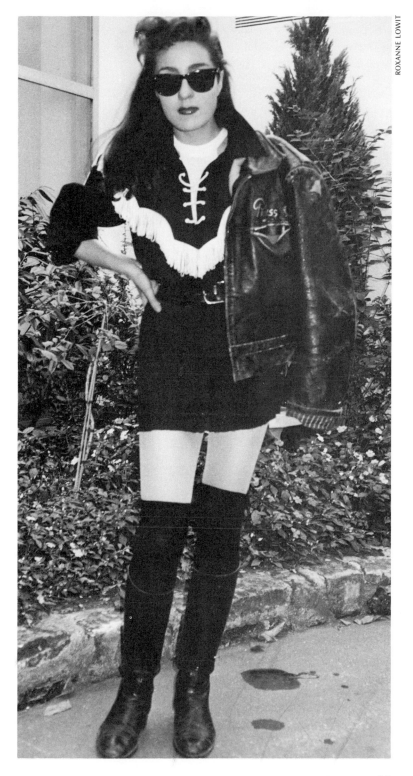

ROXANNE LOWIT

A typical Trendy loosely interprets western wear with a western shirt over a tank top over an ultrashort mini and wide belt. Tights are layered with leg warmers pulled over the knees, finished with western boots, of course. The black leather blouson is really beat up and the entire look is incomplete without dark glasses.

FRENCH FASHION TYPE: ARISTOCRAT

CHARACTERISTICS: At night, the Cinderella-like aristocrat is larger than life, extravagant and an entrance-maker. She is the "grande dame" (a carryover from the French court, perhaps). During the day, however, you might not recognize her, for she tends to dress as the most conservative Continental Preppie imaginable in sensible tweed skirts and cashmere sweaters that look as if they have been in the family for generations. On rare occasions, however—an upscale lunch or meeting—a couturier suit may be called for.

SHOES/HOSIERY: Sheer stockings; classic low-heeled pumps; boots—but only in the country.

JEWELRY/ACCESSORIES: Masses of dazzling jewels when dressed up, otherwise grandmother's gold ring and earrings.

HANDBAGS: Hermès "Kelly" bag; a small crocodile or alligator shoulder bag.

COLORS: The classics—black, white, gray, burgundy, beige, navy—plus purple and red.

PERFUMES: Cabochard by Grès; Jickey by Guerlain; Mme. Rochas by Rochas.

FAVORITE DESIGNERS: Jacqueline de Ribes, Alix Grès; Jean Louis Scherrer.

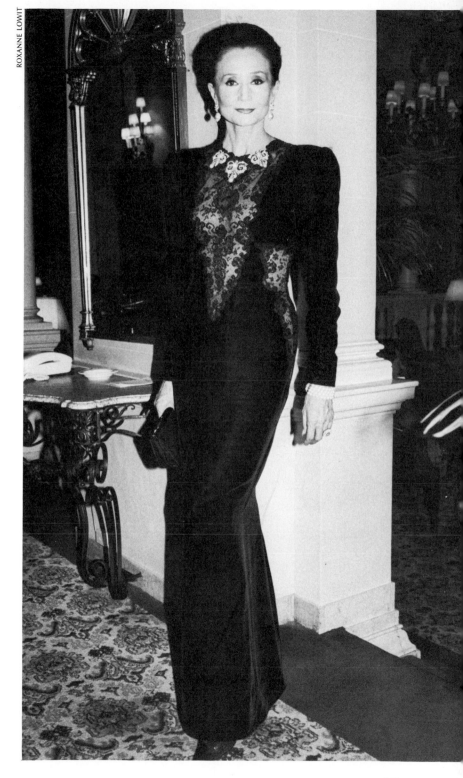

ROXANNE LOWIT

Jacqueline de Ribes is not only one of the aristocrat's favorite designers, but a favorite aristocrat. She's pictured in typical aristocratic evening garb—an entrance-making gown of her own design.

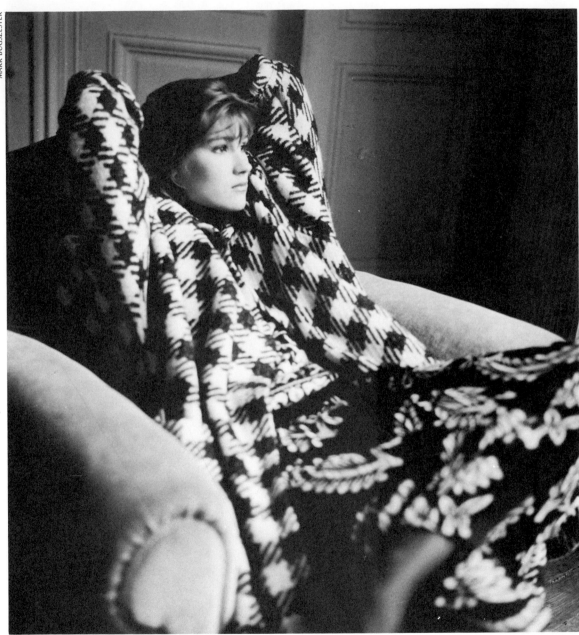

2

STICK TO NEUTRAL SHADES

French favorites, black and white, look smashing when paired and patterned. The pieces themselves are classic and work well with solid colors when the wearer wants to make a quieter statement.

ONE of the cornerstones of French chic is the use of understated color. In an effort to shy away from the obvious, Frenchwomen opt for subtlety in both the style and color of their clothing. They base their wardrobe on one or two neutrals—black, white, gray, hunter green, navy, beige and tan—and the varieties of shades and tones of each, which they frequently and harmoniously combine. Neutrals provide the Frenchwoman with a perfect background for the special accessories and touches of color she can use to create an image that won't obscure her individuality. There are at least four practical reasons for starting with a neutral wardrobe:

1. THEY GIVE YOU MORE FOR YOUR MONEY: The clever use of color can stretch a franc, or a dollar. By skillfully blending tones of one neutral to create an ensemble, you can create a strong, rich total look—and personal statement—with less expensive individual pieces. What to wear to a casual Saturday night dinner party? If you apply the preceding logic to fashion an outfit built around beiges, it could be an old pair of camel gabardine trousers, an ivory man-tailored shirt, a beige cashmere cardigan, a golden chain around the waist, then several chains mixed with long strands of pearls around the neck, cream lace socks or pantyhose and tan heels.

Neutrals are also extraordinarily versatile, especially in the classic shapes the French are so fond of. They can be dressed up or down, often with just the switch of a scarf and shoes: the same outfit we discussed above would work in an office if you substitute more tailored pantyhose and shoes, a leather belt, and a subtle print scarf worn as an ascot in place of the chains and pearls.

2. LESS LOOKS LIKE MORE: Neutrals lend themselves to myriad combinations, so that far fewer pieces give the illusion of much, much more. Take the black skirt pictured, for example: pair it with a different top and accessories and it can work every-day of the week. You couldn't get the same fashion mileage from a skirt in a pattern or in a bolder color.

3. YOU LOOK MORE MONEYED: Neutrals are ele-gant, and elegance looks expensive. Black and navy always look rich, as does white, especially when worn unexpectedly, in win-ter, for example . . . and when the ensemble is composed of pieces that vary slightly in tone and fabric.

KEITH TRUMBO

Neutrals are tremendously versatile: the same black skirt works for two very different occasions when you change the details, including hair and makeup. For sport: a heavy black sweater, black pantyhose and a big pin, worn with less makeup and a young, carefree coif.

4. THEY WEAR FOREVER: Neutral colors are classics—they endure. To quote Azzedine Alaïa, the designer who put black leather on every Frenchwoman's most wanted list: "You get tired of bright, violent colors. Those that are subtle and simple are for keeping a long time." And because they are so unassuming, neutrals usually mix wonderfully with the "hot" color of the season. In fact, another one of the secrets of chic is to use a trendy hue to "update" an essentially neutral palette. Wear it as a scarf, belt, a handkerchief tucked in a blazer pocket, headband or vest—the list of possibilities is endless.

KEITH TRUMBO. COURTESY COSMOPOLITAN.

For evening: a white silk shirt, bold jewelry, sheer hosiery and a silky shawl, with more defined makeup and hair.

Actually, the French use color—or the absence of it—to create a personal signature, but only if it flatters the wearer's own coloring. Designer Sonia Rykiel is a case in point, She dresses exclusively in black, explaining: "I always dress in black because I have red hair and black works for a redhead. But I think colors are important in a wardrobe because they provide the touch that wakes up black." And while image counts most for the majority of women, ease is also important. Many women love the idea of a uniform—the same style navy sweater and slacks, for instance, in a host of fabrics. Whatever the reason, the French seem to have an instinctive understanding of the psychological associations and responses to color: they use color quite deliberately to arrive at exactly the effect they want.

THE CHIC MYSTIQUE OF BLACK AND WHITE

While navy is a classic, gray looks great for most occasions, and beige is easy to combine, black stands out as the hue most responsible for the French chic mystique: think black sheath, a sexy variation of the little black dress, black turtleneck and skirt, black beret, bikini, Chanel bag. It's the color most Frenchwomen wear for day in winter, for dress year-round. White, especially for warm weather, runs a close second. "A black base in winter and a white one in summer are essential in a wardrobe," confirms designer Popy Moreni.

While Parisians usually take their color cues from the season, they occasionally reverse the order. And it works beautifully because black and white are essentially seasonless. And what could look fresher on a dreary winter day than all white? Or more sophisticated in summer than black?

Think chic, think Brigitte Bardot in the simplest black sheath imaginable.

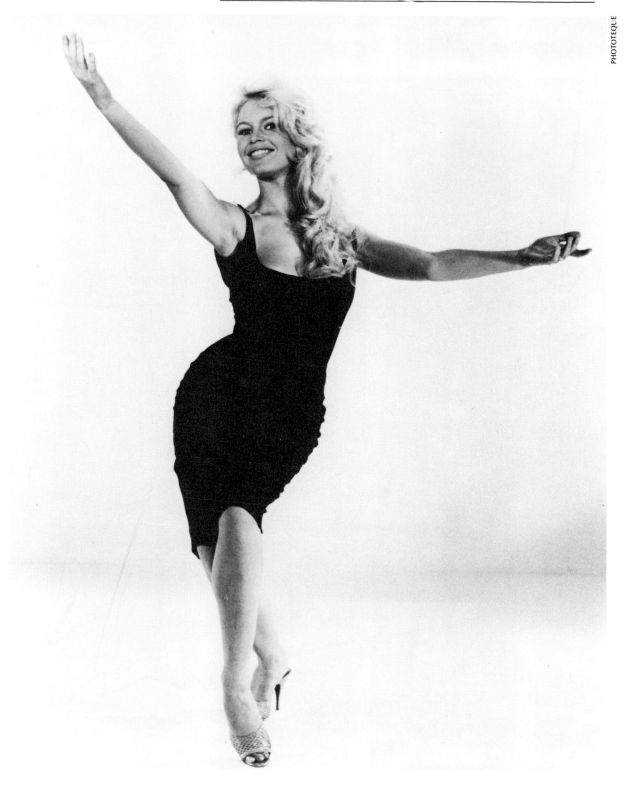

ROXANNE LOWIT

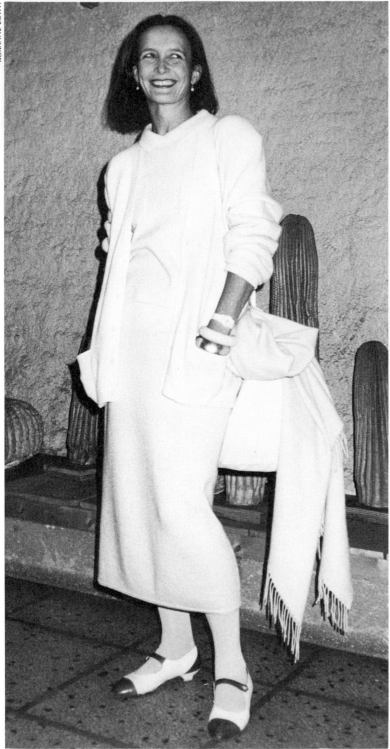

The positive power of pure white in winter. Here, the whole looks marvelously fresh and inordinately rich because of color, although each part may not have cost very much.

22

DRESS BLACK

Neutrals not only smarten up a wardrobe, but simplify the planning of it as well, so that everything will go together beautifully. Take a basic black wardrobe, built around seven classic pieces: pleated pants, a pleated skirt, straight skirt, sweater dress, cardigan, vest and blazer. With the addition of a few accents—two blouses, one in silk, one in cotton, a T-shirt and an assortment of accessories—you can achieve an entire array of different looks for both summer and winter. For warm-weather dressing, select basics that are linen, cotton and cotton knit; for cold weather, wool flannel, wool gabardine, wool jersey, lambswool and cashmere.

And while you can stick to neutrals in your choice of accessories, a touch of unexpected color will add interest. If you look too washed out in black, break it up with color close to your face —a bright blouse or scarf or hair band to complement your complexion.

Incidentally, this wardrobe will also work in *any* neutral color, or in a combination of two complementary neutrals, like navy and white, tan and beige or gray and cream. When mixing colors, however, you will find it easier to achieve a balanced look if your bottoms—pants and skirts—are darker than your tops.

The following plan is essentially seasonless if you adapt the fabric of your basic pieces to your climate, although both lightweight wool and cotton knit will work year-round:

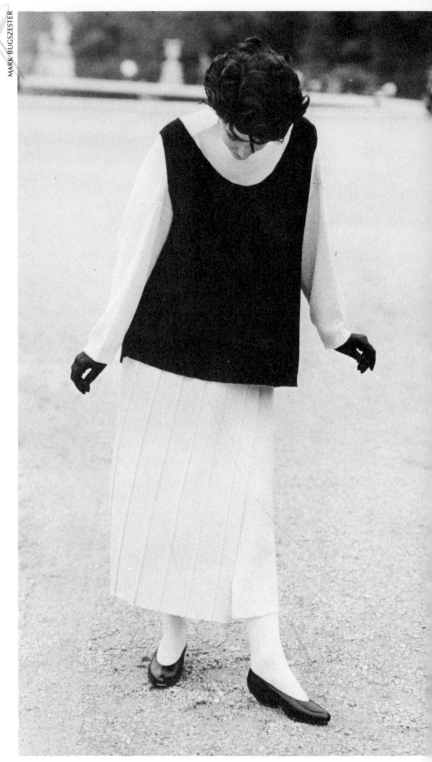

Pair a dark color on top and a light one on the bottom and you risk looking bottom heavy, since darks recede and lights dominate. Step into dark shoes, however, and *voilà* —the look is balanced.

24

THE BASIC BLACK WARDROBE

	PLEATED PANTS	PLEATED SKIRT	STRAIGHT SKIRT	SWEATER DRESS
JACKET	Cotton shirt	T-shirt	Silk shirt over	Cinch belt
	~~Brooch at throat~~	Wide belt	lace camisole	Short gold chains
	Long strand	Bangle bracelets	Pearl earrings	at neck
	of pearls	Hermès scarf	Sheer stockings/	Gold earrings
	Pocket square	at throat	pumps	and bracelets
	Thin lizard belt	Lace hanky	Flower in pocket	Ribbed pantyhose/
		Opaque pantyhose	~~Pearls as belt~~	heels
	Lace socks/loafers	Ballerina flats		
	Leather shoulder	Chain-handled		
	bag	bag		
VEST	T-shirt	Silk shirt	Cotton shirt	Scarf as ascot
	Brooch at shoulder	Several chain	(tails out)	Slouchy socks/
	Masses of	belts	Masses of short	loafers
	bracelets	Short chain	pearls	
		necklace	Opaque pantyhose	
	Schoolbag	Gold button	Lace-front shoes	
	Bow in hair	earrings		
	Slouchy socks/	Lace stockings		
	loafers	Low boots		

	PLEATED PANTS	PLEATED SKIRT	STRAIGHT SKIRT	SWEATER DRESS
CARDIGAN	Cardigan worn backward	Cotton shirt	Silk shirt	Cardigan tied over shoulders
	Shoulderful of brooches	Man's tie with tie bar	Flower at throat	Chain or leather hip belt
	Pearl earrings	Oversize watch	Chains at waist	Big hoop earrings
	Sheer pantyhose	Ribbed socks	Lace pantyhose	Opaque pantyhose/ low boots
	High-heeled slingbacks	Loafers	Ballerina flats	
	Small clutch	Schoolbag		

COLOR COUNTS

The world, according to the French, is not *totally* black and white. It contains shades of gray . . . and navy, taupe, tan, brown, even burgundy, as well as bright red and brilliant cobalt blue, which have become, over the years, the new neutrals. And while they're clever at combining these neutrals, and tones and degrees of them, the French are also skilled at integrating secondary colors into their palette in a variety of surprising ways that you might want to try:

TEN WAYS TO CREATE COLOR CHARISMA

1. A French favorite: Dress completely in the same color from your shoes and stockings on up, including your handbag.

2. Mix vibrant colors: a green sweater, a red belt, a bright blue blazer, yellow gloves . . . using a neutral, like a brown or gray skirt, as a foil.

3. Dress in brights or whites when it rains.

4. Blend soft pastels that have the same color intensity—pale peach, aqua, butterscotch, celadon, mauve.

5. Make any neutral work for you by wearing a shade that flatters your coloring close to your face.

6. Wake up a neutral outfit with shoes in an unexpected color —purple suede, for example.

7. Accent blue or green eyes with turquoise—a scarf, belt or bracelet. Make it your signature and wear a hint of it daily.

8. Just a touch of the season's most important color, in the form

of a sweater, shirt, shawl or cowl, is enough to update your wardrobe in a flash. If it doesn't flatter your complexion, wear it far from your face—in the form of a belt, bag, pantyhose or socks.
9. Blend unexpected neutrals—black with brown, black with navy; brown with navy, brown with red, brown with burgundy; taupe and gray, beige, burgundy, black, navy. Accent with a bright or a metallic tone.
10. Don't underestimate the power of a *pochette* . . . a brilliantly hued handkerchief or small scarf fluttering from the pocket of a shirt or blazer.

COLOR ACCENTS

The successful use of color is almost instinctive to a Frenchwoman, thanks to a culture rich in art and architecture and an environment abounding in natural splendors, both of which her eye has become accustomed to. But her attitude also contributes to her expertise and inventiveness: she feels totally at ease mixing and experimenting with colors. Once she establishes her base, she will play with colors until she arrives at that special splash that will make the difference!

No matter what your background, however, here are some of the ways you can become inspired:

—Get an assortment of paint chips and hold them against the colors in your wardrobe to find combinations you might never have considered.

—Keep your eye open for interesting color pairings when skimming fashion magazines; save the pages for reference.

—Look at art and decorating books for inspiration. The color combinations of the Memphis movement, for example, like red, pink, black and turquoise or aqua, green, yellow and pink offer exciting possibilities.

—Pull an assortment of clothes and accessories in different colors from your wardrobe and spread them out on the floor. Then try combinations that you might not have considered when everything was hanging in your closet.

You can also pep up your neutrals by accenting them with a few of the following colorful suggestions:

BLACK: any bright or pastel. Of special interest: pistachio, chrome yellow, pink, apricot, turquoise.

WHITE: any bright or pastel. Royal blue and emerald green look especially fresh.

NAVY: white, fuschia, lime green, orange, copper, rose.

BROWN: lime green, pink, baby blue, aqua, chrome yellow, red, cadet blue, light purple, butterscotch.

BURGUNDY: pink, pumpkin, pale blue, peach, fuschia, red.

BEIGE, TAN: ivory, butterscotch, camel, peach, pumpkin, olive, red, orange, any heathery hue.

RED: chrome yellow, orange, fuschia, cadet blue, purple, pale pink, turquoise, lime green, olive, pumpkin, gold.

CADET BLUE: black, brown, white, lime green, red, burgundy, bright violet, butterscotch.

GRAY: pink, fuschia, orange, purple, burgundy, red, sage or hunter green, pumpkin, brown, baby blue (any soft pastel), silver, cream.

TEXTURE

A monochromatic color scheme is a French favorite. It gets its punch from contrasts in the textures of fabrics—rough and smooth, shiny and matte, flat and raised—that are often all jumbled together. There are no rules. There is no order. And this disorder creates a charming mix that looks spontaneous, whether or not it's been carefully planned. It also simplifies shopping, since colors don't have to match exactly to work together. And the slight tonal differences that result from mixing textures tend to give the total look a richness that would otherwise be missing if all shades and fabrics were uniform.

You too can succeed with an array of interesting textural mixes if you experiment with what you already own, then buy for texture. To get on the right track, start with these tried-and-true combinations, which are divided seasonally:

SPRING/SUMMER FABRICATIONS

- Satin/denim
- Gauze/linen
- Cotton knit/cotton gabardine
- Sweatshirting/cotton batiste
- Cotton and ramie/silk
- Organdy/damask

FALL/WINTER FABRICATIONS

- Cashmere/silk
- Lambswool/satin
- Tweed/suede
- Shetland/corduroy
- Sweatshirting/cashmere/ribbed cotton knit
- Flannel/tissue linen

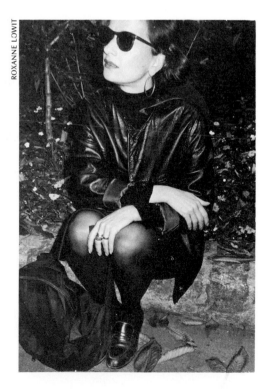

ROXANNE LOWIT

A study in contrasts: the mix of textures gives this all-black ensemble—a cotton turtleneck, wool flannel skirt and leather jacket—added interest.

PATTERN

Although she wears a predominance of solid colors, patterns are often responsible for the panache in a Frenchwoman's wardrobe. The smaller, more understated and classic patterns, like tiny checks and polka dots, foulard prints and paisleys are most popular and look most elegant. They do not date, and are easiest to integrate in an overall look. Flamboyant and adventurous patterns tend to show up as accents—a handkerchief, scarf, belt, even a blouse—more frequently than as total ensembles, except when the wearer wants to turn heads or finds a look irresistible, has lots of disposable income and/or is an ardent fan of one—or all—of the masters of print mixing: Ungaro, Kenzo and Yves Saint Laurent, who do it like no one else can!

* KENZO—Kenzo's designs are the most youthful and affordable of the three. His folkloric prints, splashy scarves and shawls in brilliant colors are fun to wear, especially when combined with one of his striped or tweed jackets.

* UNGARO—He is the unexcelled master of outsized prints in brilliant colors, which are often combined with dots and stripes or positive/negative florals. The fabrics and workmanship are ultraluxurious, and the silhouette is ultrafeminine, so that the clothes never look like they are wearing the woman.

* YVES SAINT LAURENT—Saint Laurent often integrates two or three patterns at a time into an ensemble, unified by color or form. An often-repeated favorite is a positive/negative pattern in black and white. And because his fabrics and the fit are so exacting, even the biggest, boldest prints look posh.

Unless, however, you are truly skilled at mixing patterns, or you fall head-over-heels with a print that will work wonderfully with something already in your wardrobe, use prints and patterns sparingly.

CHANGING PATTERNS

Appropriateness as well as beauty are the demands the French make upon patterns. They thus take into account the fact that subtler prints, since they are never overwhelming, last longer, look richer and are usually more flattering for the majority of body types. But if a bold pattern piques their fancy, they throw caution to the winds and wear it joyously.

Nevertheless, pattern choices are for the most part conservative. That way, the more they mix, the merrier. While one outfit can contain an array of patterns, it is always unified by its color scheme. Here's a brief rundown of favorite patterns and some ways to pair them:

STRIPES: try combining a fine pinstripe with a pastel floral in cream, pale blues and pinks; bolder, broader stripes with checks and polka dots, i.e., checked skirt, striped shirt, polka-dot scarf, in black and white with a flash of color.

CHECKS: checks and paisley make a pretty combination . . . the smaller the check, the smaller the paisley and vice versa. One outfit to try: tweed skirt, checked blazer, paisley shirt in browns and rusts, with a touch of hunter green.

PAISLEYS: paisley and plaid or tweed are fashion perennials. This ensemble may seem to recall Old England, but the French love the look: a pale, pin-striped shirt, paisley foulard, solid cashmere cardigan, plaid pleated skirt, tweed or solid color jacket. This could be built around navy, burgundy and camel.

FLORALS: A favorite is to mix different size florals in the same look, all in an identical color scheme or the same floral in differing color schemes. Florals can work well with stripes, even checks, especially if the colors are the same.

PLAIDS: Plaid is so prevalent, teamed so often with other patterns, that it almost doesn't count as a pattern. A favorite is a black/blue/green Black Watch plaid pleated skirt, worn with a pin-striped shirt, a sweater and a blue blazer. Plaids and tweeds also complement each other.

JACQUARDS/ARGYLES: These patterns are usually reserved for sweaters and socks, and combine beautifully with tweeds and subtle plaids.

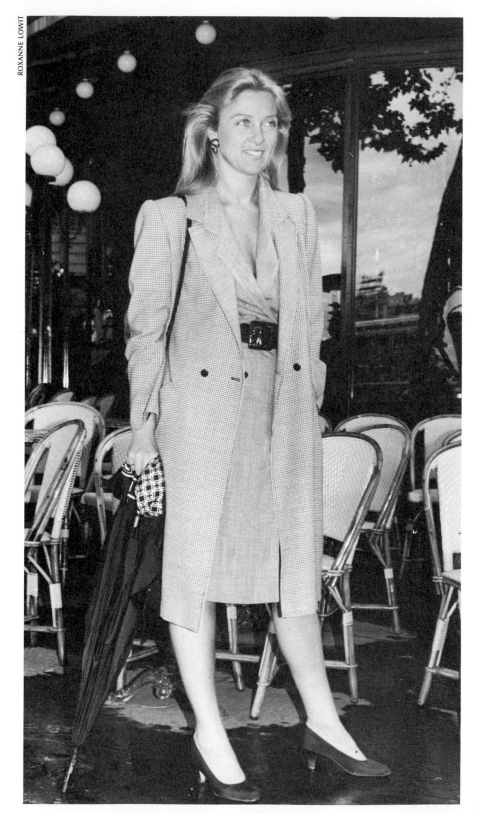

ROXANNE LOWIT

This ensemble features a subtle interplay of pattern and texture: the textured dress fabric looks almost patterned, especially when paired with a checked coat. A bolder-patterned scarf that can be tied around the throat adds a lively note.

A jumble of prints with a folkloric feel livens up a gloomy winter day. The patterns are all different, but the color scheme is the same.

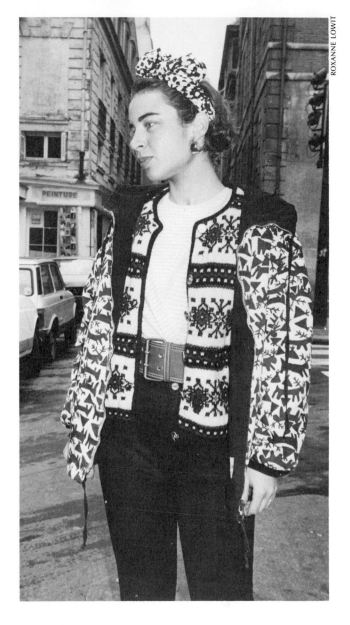

ROXANNE LOWIT

DOTS: From pin to quarter size, the French are dotty about dots. One good-looking way to wear them is positive-negative: black on white dots teamed with white on black dots. Dots of different diameters—a pin-dot T-shirt, giant dot pants, mid-dot head band—are also eye-catching. Dots combine well with stripes (dot top, stripe bottom) and checks (checked jacket, dot cummerbund or tie).

33

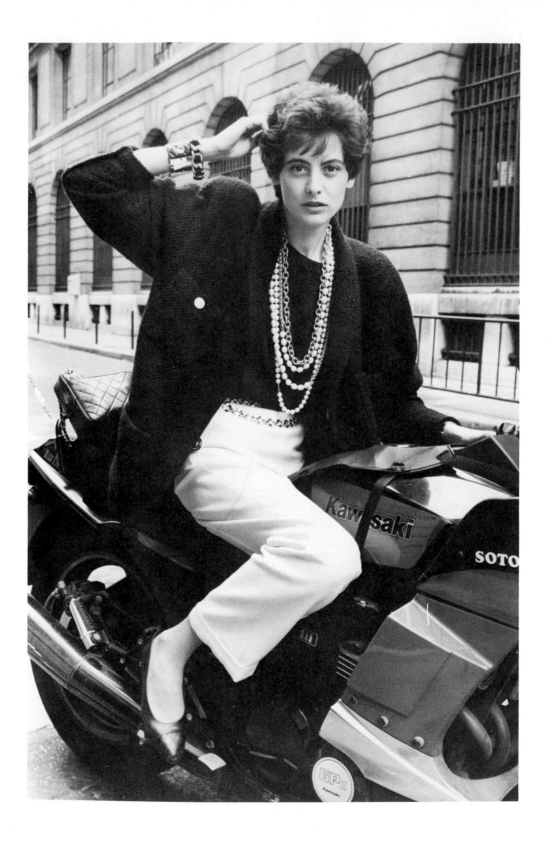

3

INVEST IN A FEW WELL-CHOSEN CLASSICS

Typical of French chic: the wear-everywhere classics that work, play and go out at night in beautiful style. Start with pants and a simple pullover, top with a blazer or suit jacket. For an amusing change of approach, switch accessories: instead of pearls and chains, add a scarf or muffler around your throat and an oversized pin in the shape of a lizard or airplane high on your shoulder.

WHAT do a Continental Preppie, a rue du Faubourg St.-Honoré Sophisticate and a Les Halles Trendy have in common? Probably a Hermès scarf, a black skirt and V-neck sweater, a pair of jeans and a few white T-shirts! Because French chic, no matter how unique a woman's ensemble, is fundamentally classic. Frenchwomen, regardless of their fashion type, their profession or income level, build their wardrobe around a small core of carefully chosen, wear-for-years classics, which they then update and individualize by adding their personal touches, a sprinkling of the season's "hot" items that strike their fancy and a few unexpected extras. So, if you want to put yourself together with French flair, start with the classics.

Valuing things that last and improve with age is an essentially European notion, but it makes sense for Americans too, especially now, with the soaring costs and short lifespan of clothes. Classic pieces have staying power. They are simple, versatile and easy to integrate. A few go a long way. Since they can make do with less, Frenchwomen feel they can spend more on each individual item.

If you stop to analyze a best-dressed wardrobe, you might be happily surprised to discover that it revolves around a base of only seven essentials—plus eight extras that you'll learn about in the following chapter. This fact is perhaps not readily apparent because of the clever ways the pieces are combined and accessorized. But because these are *"les musts"* that make or break a look, the French try to buy the single best piece in each category, concentrating on top-notch tailoring and fine fabrics in natural fibers, like the softest cashmere, the smoothest flannel, the silkiest gabardine. Not stinting—sometimes spending a bit more than you think you can afford on the few quality items that set the tone for the rest of your look—is fundamental to French chic!

A STYLE-SAVER

If you feel that a pure cashmere or silk sweater is a sacrifice you are not prepared to make, even for the sake of chic, try this tip from stylish Parisians on a budget: capture the spirit of the high-priced piece by duplicating the style in a less expensive fabric—lambswool instead of cashmere, a silky cotton instead of its more costly counterpart.

THE SEVEN ESSENTIALS NO WELL-DRESSED FRENCHWOMAN WOULD BE WITHOUT

1. A Black Straight Skirt
2. A V-neck or Cardigan Sweater
3. A Suit
4. A Pair of Jeans
5. A Silk Shirt
6. A Couple of White T-shirts
7. An Hermès Scarf

A BLACK STRAIGHT SKIRT: this is a wardrobe staple for all age groups. Worn slim and snug, a millimeter short of skintight, it is often quite pegged at the bottom and has a back slit to draw attention to the derriere and legs, those parts of the anatomy Frenchwomen like to emphasize most. Length is not an issue. Generally, the shorter the skirt the younger or more fashion forward (depending upon the trends of the time) the wearer. The all-time safest length hovers around the knee, but mid-calf is also a favorite and can go anywhere, depending upon how the skirt is topped. An oversized shirt makes the look trendy, while a slim, spare sweater brings it back into the classic realm.

In winter, favored fabrics for a black skirt are flannels, gabardines and knits; in summer, lightweight wool gabardines, linens, cottons and cotton knits. Black leather—the French are crazy about black leather—is worn all the time, except on the steamiest summer days.

THE BEAUTY OF
A BLACK SKIRT

Here are a few ways the straight black skirt takes to the streets of Paris:

—Elegant: Designers Myrène de Prémonville and Gilles Dewavrin team the narrow skirt with a long, semifitted tunic jacket. Long over short—or short over long—is a favorite way to play with proportion. Dark hose, shoes and gloves finish this understated look.

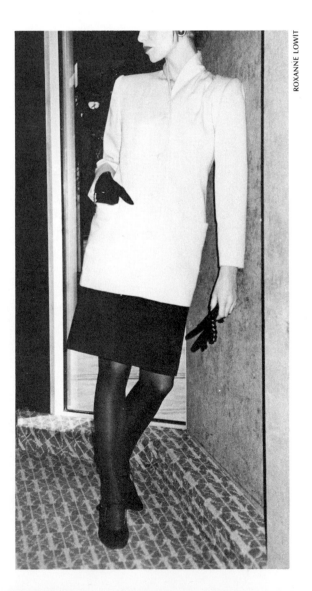

ROXANNE LOWIT

An elegant look based on a black skirt.

37

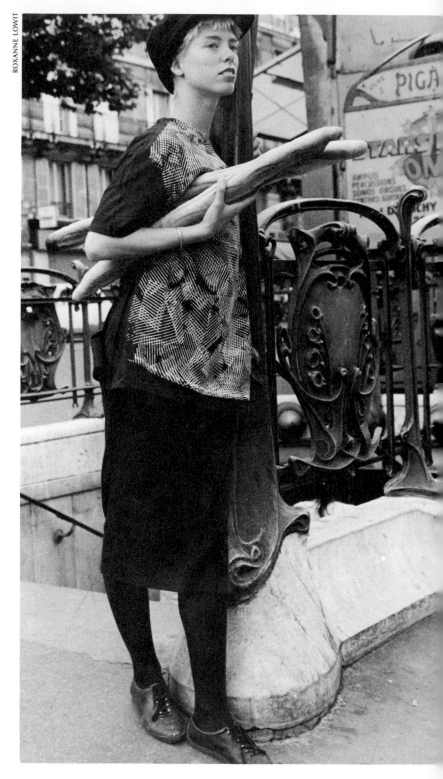

ROXANNE LOWIT

A Pop-Art top gives the black skirt
an eccentric appeal.

38

ROXANNE LOWIT

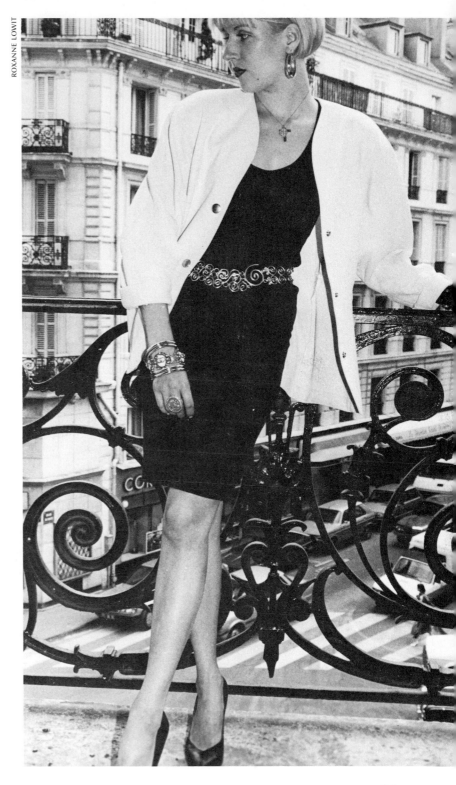

The easy, warm-weather way to wear a black skirt.

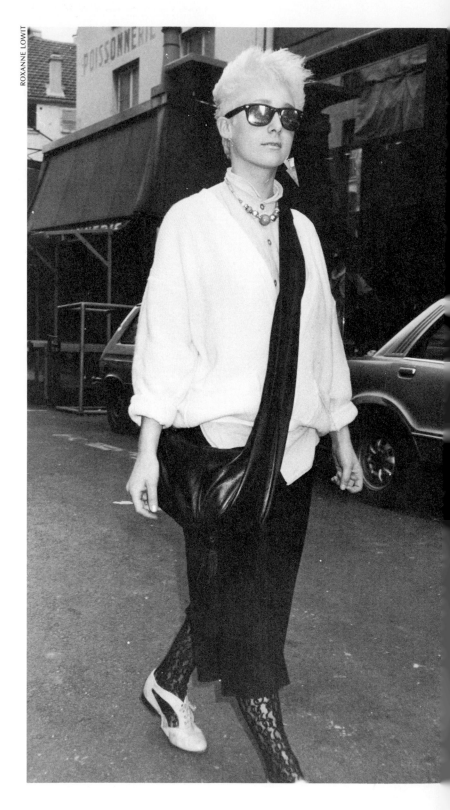

ROXANNE LOWIT

Seen around town—one young
way to wear the cardigan is over a
skinny black skirt and man's shirt
with shirttails out, plus an
oversized shoulder bag worn
bandolier-style, black lace
pantyhose and white shoes.

40

—Easy: A perfect warm-weather look. Paired with a tank top and simple jacket, the black skirt looks dressed up enough to go dancing because of the wealth of interesting accessories: the filigree belt, oversized ring and bracelets, giant earrings.

—Eccentric: For the young . . . or young at heart. Topped with a Pop-Art patterned, short-sleeved T-shirt. Details include a jaunty cap, black pantyhose, flat shoes . . . and don't forget the baguette!

A V-NECK OR CARDIGAN SWEATER: These two sweater styles are usually collected in multiples because of their versatility. And they are worn in the same manner by all age groups: slightly big and baggy, but not too bulky to slide under a blazer or suit jacket. To get just the right fit, women often buy them in men's sizes.

Lambswool and cashmere are preferred, although an alpaca cardigan is always coveted. All work in cool weather throughout the year. During those hot summer days, savvy Frenchwomen trade in their sweaters for cotton tank tops.

NEW OPTIONS FOR AN OLD SWEATER

—Over a pullover in the same shade to create your own sweater set.

—Over a lace camisole or bare skin for evening: fill in the neckline with a profusion of pearls.

—Trimmed with a long lace collar around the neckline, a big brooch and a long strand of pearls.

—Worn backward at night over silk or satin trousers.

—Teamed with a plaid shirt, a different plaid skirt and a tweed jacket, for an unmatched suit look.

—Slung on like a scarf, with the sleeves tied around your throat.

—Twisted, then knotted around your waist like a belt.

A SUIT: A suit is for many women, and designers alike, the mainstay of a chic French wardrobe, not only for its versatility, but also for its stylishness. Myrène de Prémonville and Gilles Dewavrin, two hot designers who used to be a team, talk about the suit as the symbol of French style: "Couture gave the French [their] style, in a way, by defining a certain notion of quality, elegance, and cut, as evidenced in a suit. Say 'France' and we

The suit, *à la* Givenchy. Although the silhouette is structured, the wide shoulders, nipped-in waist and short slim skirt emphasize female curves, making the wearer look ultrafeminine.

think 'suit' . . . a kind of tight-fitting suit with a hat." Designer Thierry Mugler, whose suits are as sexy as they are chic, agrees, acknowledging their practicality as well as their aesthetic appeal: "For me, a suit is not only the most Parisian element in a wardrobe, but the most important one, because of all the ways you can wear it—open or closed . . . over a black leather or a red lace bra, or, for a complete change, [with] a crisp white cotton shirt."

Whether she selects a skirt or pantsuit depends upon her own taste, but in either case the Frenchwoman does not feel compelled to always wear the suit as an ensemble. She increases her wardrobe options by pairing each piece with whatever else in her closet she thinks will complement it, and making each outfit special through clever accessorization.

Because it takes them through summer and winter, the French like the suit in a lightweight wool gabardine, a wool crepe or a wool-and-silk mix. Otherwise, fabric choices follow a seasonal pattern: heavy tweeds, wool flannels, wool gabardines, wool/cashmere blends and wool knits during the cold months; cottons, linens, silks and cotton knits when it gets warm.

Suits come in all styles but those with a menswear feel seem to be favored, as long as the final effect is feminine. This is influenced by fabric, fit, accessories, even hair and makeup, as you can see by these three different looks:

FOLLOWING SUIT

—THE SIMPLE PANTSUIT, worn by actress Anouk Aimée. French twists: the feminine cut—elongated lapels, slightly puffed shoulders on an otherwise severe suit; the pattern/fabric mix (try stripes and small checks for a change); the deliberate lack of jewelry, save for a delicate clip at the neckline—an unexpected and pretty detail.

How to quick-change this suit for evening—with a white silk, pleated tuxedo shirt, a cummerbund and ribbon bow tie, sheer black lace hose and silk high-heeled pumps or sling backs. Pin a flower on your lapel.

—THE SPARE SKIRT SUIT, worn by actress Stephane Audran. French twists: an untied tie and casually opened man's shirt, adorned with ropes of chain and pearls; a hair-bow; the

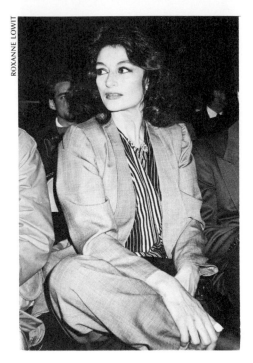

The simple pantsuit.

glamour-girl fur thrown over the shoulders; sexy high-heeled pumps.

How to quick-change this suit for evening—with a black lace or black leather bra or bustier slipped under the jacket, oversize rhinestone or gold and pearl earrings, black gloves with a ring and an armful of bracelets over them, sheer lace pantyhose and dressy high heels.

—THE STRICT SUIT, slightly oversized and worn shirted and tied. French twists: the play of masculine/feminine—the shirt and tie offset by the swingy skirt, which softens the silhouette; fishnet stockings with front-tie, pointy-toe ankle boots that are graceful rather than clunky; a soft curly hairstyle, pretty makeup.

How to quick-change this suit for evening—with a long, lean sleeveless silk-knit tunic in a pale shade, wrapped with ropes of chains at the hip or long ropes of chains and pearls around the neck—or both; oversized earrings; a wide bracelet cuff on each wrist; sheer black hose and delicate, strappy sandals—either high-heeled or flat.

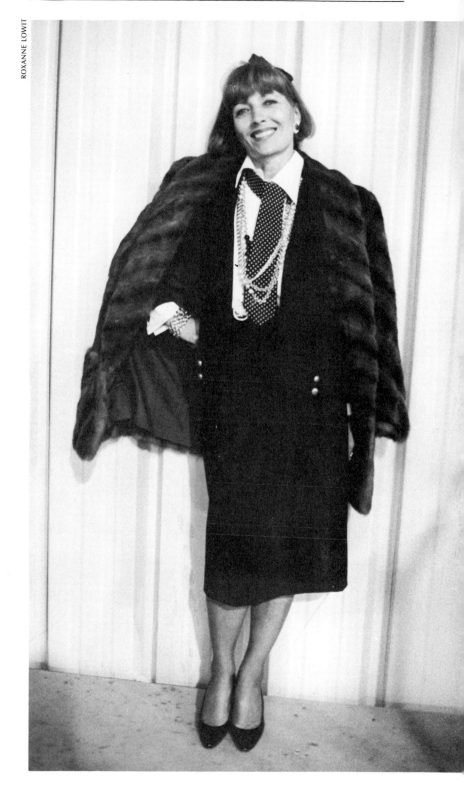

ROXANNE LOWIT

The spare skirt suit.

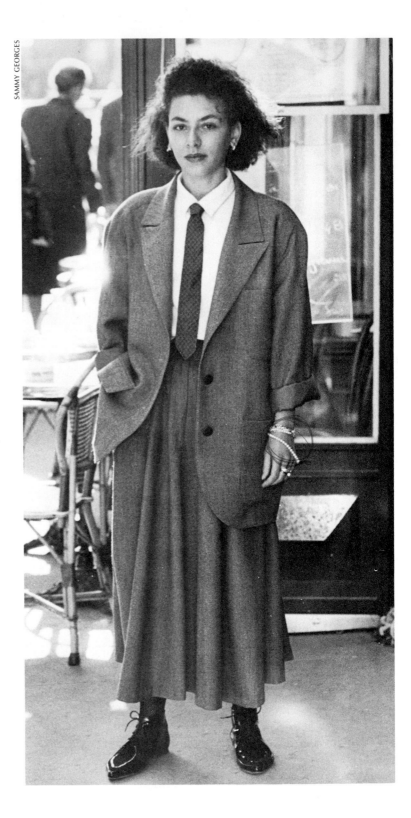

SAMMY GEORGES

The strict suit.

A PAIR OF JEANS: Leave it to the French to make an American classic chic and sexy. Jeans no longer make news in Paris—except for the occasional newspaper or magazine article announcing their demise. But if you judge from the proliferation of denim everywhere you look, jeans appear to be as popular as ever. Every self-respecting French man, woman and child has a pair, and a fashionably faded pair at that. Levi's are popular, but more often than not jeans bear the label of Paris's reigning royalty of blue denim, designers François and Marithé Girbaud, who are credited with starting jeans fever in France.

The quintessential French jeans—whether or not they were made in the USA—are worn tapered and fitted to follow body curves. They are often worn short—about two inches above the anklebone—or longer and rolled up so that socks or stockings show.

They are also worn true to style. The Trendy often tops them with her boyfriend's or husband's shirt or sweater and a big black leather blouson; the Preppie pairs them with a Lacoste-style polo and cowboy belt, or a white T-shirt and V-neck sweater or vest; the Sophisticate slips them under a luxurious silk shirt and beautifully tailored blazer. The finishing touches include cowboy boots, sneakers, tailored flats, socks and loafers—and another French twist: lace or fishnet stockings and heels.

A SILK SHIRT: They may have to scrimp on other things in order to buy a designer version, wait until one goes on sale or search for one in a secondhand store, but Frenchwomen insist on pure silk. And they will accept no substitutes. They know that a real silk shirt is a key item that can upgrade everything else in a wardrobe. Versatile styles have a small pointed collar like a man's shirt, or wider lapels or even a mandarin collar and an easy fit: they are generously cut to skim the body. Indispensable colors include neutrals—black, cream or white; a soft pastel, like pink; or a complexion-flattering bright, like red, royal blue, jade green or shocking pink.

Because it is such a pivotal piece, the silk shirt gets plenty of wear, in plenty of ways that would work for a woman anywhere in the world:

A typical Saturday outfit on the Left Bank—a black motorcycle jacket and worn blue jeans rolled up to show socks and sneakers.

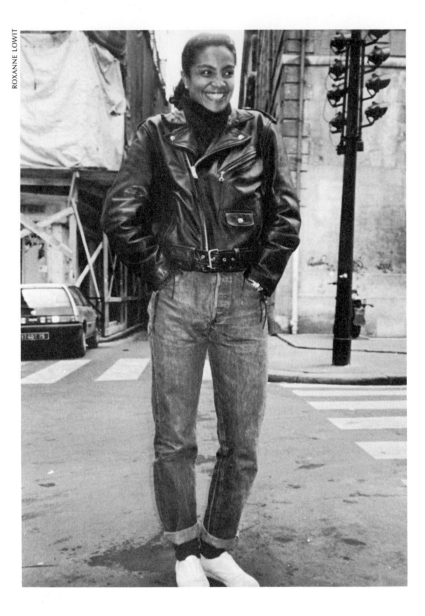

ROXANNE LOWIT

THE WEAR-WITH-ALL

—Wear the shirt buttoned up with a brooch at the neckline, a tie, scarf or ribbon.

—Button the bottom only: for evening, over bare skin, if you dare; for day, over a white T-shirt or undershirt.

—Leave it loose: wear it as a jacket over a skirt and tank top, over a skirt and another shirt, over a sweater dress.

—Instead of tucking it in, knot it over a skirt or pants.

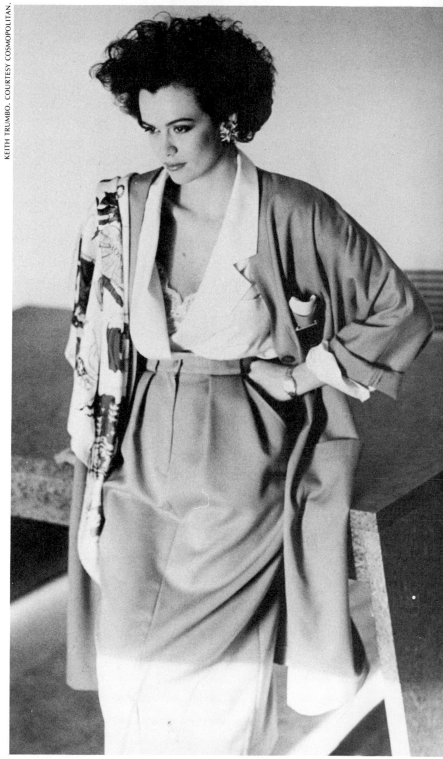

KEITH TRUMBO. COURTESY COSMOPOLITAN.

When left open over a sexy lace camisole, the silk shirt softens a sober business suit.

Play it up. Wear the T on its own, over a sporty bottom (a pair of jeans or khakis, a leather skirt or cotton summer skirt) and add jewels.

CHIC WAYS TO T OFF

A COUPLE OF WHITE T-SHIRTS: These are second nature to the French and so basic to a wardrobe that they are purchased in multiples. Why their allure? A simple white T can take the starch out of a sober business suit, for example, and the French adore contradictions. Style-setting interior designer Andrée Putman, herself a master of the unexpected touches that transform the ordinary into the rare, explains it further: "I always say to mix the poor and the rich. For fashion to work, there must be a disrespect . . . a sense of humour. A cheap T-shirt, worn with an expensive necklace and an inexpensive pin, can thus add a lot to an outfit."

A man's cotton T-shirt with a crew neck and short sleeves—the kind you can buy in the five-and-ten, by Fruit of the Loom or Hanes, packed three for eight dollars is the French ideal. It is best worn slightly oversized, so buy it even larger because it shrinks appreciably when machine washed and dried. If you take a size 4 or 6, buy a man's Small; sizes 8 and 10, a man's Medium; sizes 12 and 14, a man's Large; larger, a man's Extra-large.

Whether you wear your T rumpled or ironed is a matter of personal style. Generally, however, every French fashion type tends to iron hers, with the exception of the Trendy, but whether she does or not often depends on the prevailing fashion climate.

Suited to a T. Give any suit a fresh new appeal with a T and ascot.

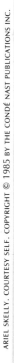

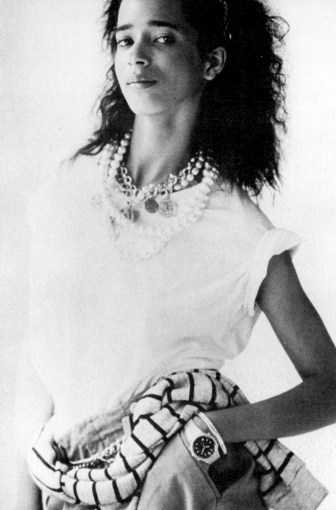

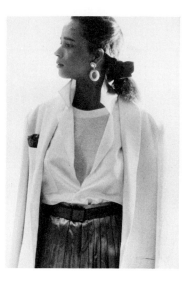

Play it down. Slip it under evening separates for a casual party look.

The bottom layer. The T as an undershirt provides a layer of chic warmth.

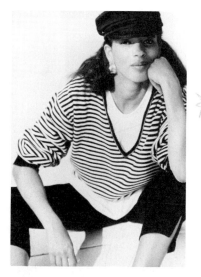

Under all. It's the ideal accent under a V-neck or cardigan.

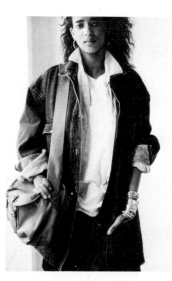

SOME OF THE WAYS TO WEAR HERMÈS

(See Chapter 6 for more.)

AN HERMÈS SCARF: Hermès scarves have been in existence for fifty years, but they probably have never before been in such demand by such a broad cross-section of the French population. You see, Hermès is a very high-class, high-priced store on Paris's Faubourg Saint-Honoré, which originally had a reputation for high-quality saddles and riding gear, then for belts and bags, scarves, ties, fragrance, and now for fashions that often involve an equestrian theme. But until a very short time ago, Hermès scarves were an item only one's mother wore. Today, mothers are having a particularly hard time keeping track of their scarves, since their daughters have discovered Hermès . . . and all that a single scarf can add to an ensemble.

To meet the current demand, there are some 750 scarf styles to select from, and a dozen new or reprinted designs are brought out each year. Although an Hermès scarf is expensive—well over $100 in America—you only need one . . . and it will last forever.

The French have made an art of wearing a scarf. As a result, there are a multitude of exciting ways to sling on, tie and knot a simple 36″ silk square. Here are a few for starters:

ROXANNE LOWIT

KEITH TRUMBO

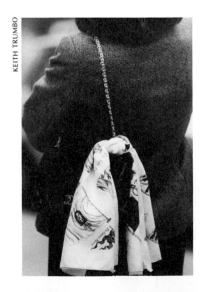

LEFT:
Tied around the hair, then knotted and bowed.

RIGHT:
Tied to the handle of a pocketbook.

Twisted and tied around the wrist like a bracelet.

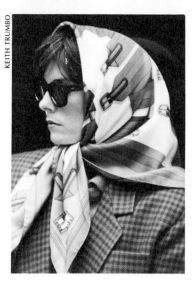

Tied under the chin, Grace Kelly style. Dark glasses are also essential.

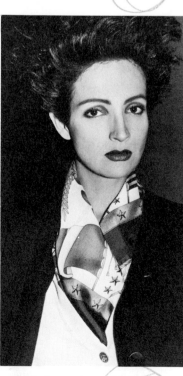

Tucked into the neckline of a vest, shirt or jacket.

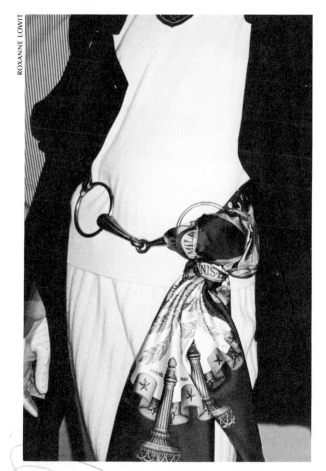

Tied to a belt, with the edges dangling.

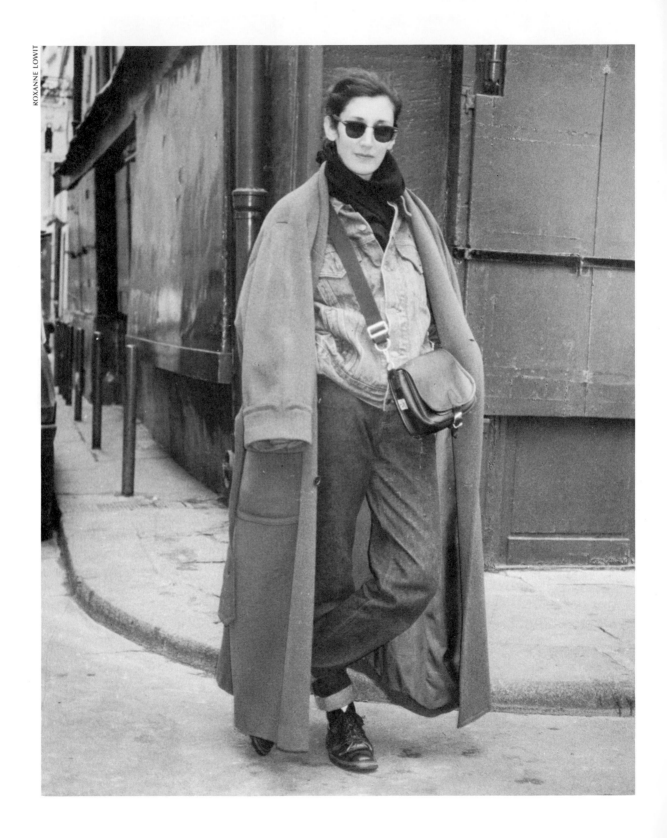

4

BUILD A LOOK WITH A MINIMUM OF EXTRAS

A basic casual look with French chic consists of layers for warmth. A big coat is thrown over a jeans jacket, shirt and jeans, then wrapped up with a muffler. The handbag is alternately worn over or under the coat.

THE seven classics you learned about in the last chapter—even though they are the quintessential items in each clothing category—do not add up to a working wardrobe. But they do form a foundation for one, which Frenchwomen then build upon with almost deliberate slowness. Their next step is to add the necessary extras—and there are eight of them—that will round out what they already own, like a white cotton shirt, a long pleated skirt, and a belted beige trenchcoat. While these are by no means the only additions they make —most French wardrobes contain more than fifteen pieces— these are the things that help form French chic. Anything else purchased depends on the wearer's work, life and fashion needs.

When selecting the extras, Frenchwomen follow the same guidelines they did with their essentials, concentrating on the simple, classic and well made. The extras, too, tend to be neutral, so that the wearer's personality is apparent in the way she combines and accessorizes them. This concept of clothing as an extension of personality should be the goal of fashion, according to at least one designer. Agnès b is infatuated with neutral clothes that are not really "fashion." And, like many women with a strong personal style, she's a true minimalist. "You don't have to have a lot of clothes to look good . . . just a few basics that can be combined, added to and changed with accessories." She also advises including one piece of clothing or one outfit that really expresses who you are and that you can wear and wear. Ultimately, she feels it is up to the individual woman to wear her clothes in a manner that corresponds to her personality. "You don't have to be the same woman every day, but what you are should always be stronger than what you wear."

THE EIGHT EXTRAS IN A WELL-DRESSED WARDROBE

1. A White Cotton Shirt
2. A Pullover Sweater
3. A Full or Pleated Skirt
4. Pleated Pants
5. A Simple Sweater Dress
6. A Trenchcoat
7. A Black Leather Blouson
8. A Heavy Coat

A WHITE COTTON SHIRT: The optimum shirt is cut exactly like a man's, and worn loose and easy. A conservative style is preferred—one that is collarless or sports a small pointed or buttoned-down collar. The Frenchwoman likes to wear hers crisp and pressed, though the very young or avant-garde prefer to take the starch out of a look by wearing theirs slightly rumpled.

Although it tends to be more casual because it is made of cotton, this shirt is still worn in many of the same ways as its silk counterpart—as well as these few new ones you may not have ever considered.

THE SHIRT OFF HIS BACK

—Wear it out as pictured, over jeans or a narrow skirt, with a wide belt buckled low on the hips, and a soft crocheted scarf knotted around your throat.

—Top your shirt with a sweater, leaving tails out if you usually tuck them in, or tucked in if you usually wear them out.

—Team it with a white lace tank top or body stocking: the combination of soft and structured is very appealing.

A PULLOVER SWEATER: A pullover is another constant in a French closet. It is often crew-necked and oversize, but it can fit closer to the body or have a turtleneck. While black, white, beige, navy and burgundy are standard, Frenchwomen are also fond of soft pastels—pale pink, yellow, blue, mint green, apricot—and offbeat solids—pistachio, fuschia, turquoise—to wake up the rest of their wardrobe.

Cotton knit works in summer and winter too, particularly in the deeper shades. In cooler weather, wool and cashmere are preferred.

The man-tailored shirt is often worn out over jeans, belted at the hip and softened with a lacy muffler.

KEITH TRUMBO. COURTESY COSMOPOLITAN.

A FULL OR PLEATED SKIRT: Frenchwomen find a pleated skirt in winter and/or a full, swingy skirt in summer irresistible for those days when they want a softer, more feminine look. Either is terrific teamed with a silk shirt, pullover or cardigan sweater, or even a simple T-shirt or tank top. The pleated skirt that seems to be most flattering is usually stitched down to the hips and worn to the knee or mid-calf, where it often tops a pair of burnished leather boots. Full skirts can be short or long, usually finished with ballerina flats or lace-up espadrilles in summer.

Pleated skirt shades tend to be neutral—navy and gray are favorites—although muted plaids are popular. Fabrics include flannels, wool blends and crepes, even silk, which is worn winter and summer alike. Full skirts are usually in silky or lightweight summery fabrics like cotton gauze, in pretty solid colors or perky flower prints.

THREE WAYS
TO SKIRT
THE ISSUE

1 . DRESSED-DOWN DAY : The pleated skirt teamed with a white T-shirt and argyle vest.
2 . BUSINESS LUNCH : Topped with a blazer and wool cardigan over a silk shirt; finish with an ascot and a slim leather belt.
3 . AFTER FIVE : Paired with a lace pullover, with a length of satin ribbon bowed around the waist.

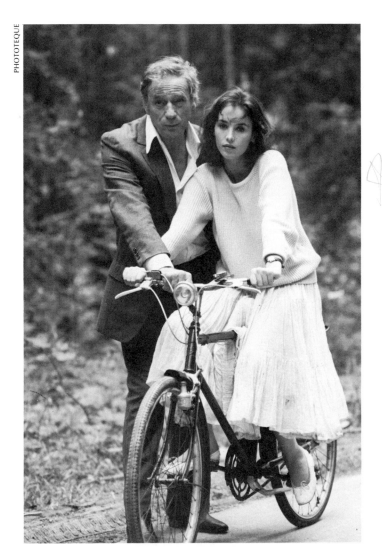

PHOTOTÈQUE

The pull of summer, pictured on actress Isabelle Adjani, shown with hearthrob Yves Montand: a loose, body-skimming "pull" over a flirty, full gauze skirt paired with ballerina flats is a typical French warm-weather ensemble.

The dressed-down pleated skirt with an argyle vest and T-shirt.

For a business lunch, pair your pleated skirt with a sweater and treat it as if it were a suit.

After five, top your pleated skirt with a feminine sweater or blouse.

PLEATED PANTS: These are tailored, fly front, with a waistband and belt loops, side pockets and stitched-down pleats, like a pair of men's trousers. Legs are straight or tapered without cuffs. Pleated pants should fit with some room to spare, so that they never pull at the pleats or thighs, but are snug around the hips and buttocks.

A lightweight wool gabardine rates high because of its seasonless nature. In winter, flannel, corduroy, velveteen and wool blends are also likely prospects, as are linens and cottons in summer. Black, beige, gray, navy and white head the list of color choices.

59

HOW TO RETHINK A PULLOVER AND PANTS

Fashion magazines in France are guiding forces in a woman's look, and the weekly publication *Elle,* with its witty approach to life's practicalities, is foremost among them. "We like simplicity with a sense of humour in fashion," is the way one of their star editors sees it. She answers her readers' questions about looking great for every circumstance—and without spending a fortune to do it—by showing them how to make a few basic pieces work in diverse ways. To put you in the same mind-set, here are several of her recommendations for adding punch and versatility to one neutral ensemble, a beige pullover and pleated pants:

THINK SOPHISTICATED: Add allure with mirrored sunglasses, chunky geometric earrings and bracelet, a slim mock croc belt, cream socks, elegant loafers and a fake fur coat thrown over your shoulders. Heighten the effect by pulling your hair back off your face into a low ponytail, adorned with a clip-on bow or tied with a scarf.

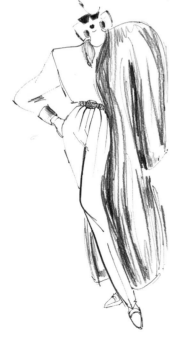

The sophisticated look is achieved with elegant accessories.

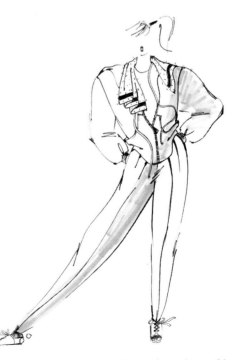

A sweat shirt and sneakers add appeal.

THINK SPORT: Zip a hooded sweatshirt over your pullover, slip into pomponned terry tennis socks and sneakers. Tie your hair back and throw a towel over your shoulders.

THINK BUSINESS: Slide a pretty shirt under your pullover, rolling up your sleeves. Add tortoiseshell glasses, an ascot at your throat, Chanel-type chains at your neck and wrist, a slim leather belt, natural-colored pantyhose, dark pumps, a small shoulder bag and an attaché case. Keep hair neat and chic with a jersey headband.

THINK WESTERN: Tuck your sweater inside your pants, and buckle on a western belt. Top with a jeans jacket and Stetson, a man's watch on a leather strap, cowboy boots, and finish with a bandanna at your throat.

THINK EVENING: Wear your sweater out and throw two long cashmere mufflers over one shoulder, caught into a multichained belt. Add long black gloves with yards of bracelets over them, extravagant earrings, black stockings, and black high-heeled evening sandals. Wear your hair swept up into a French twist.

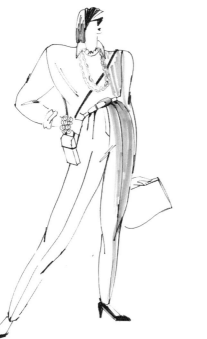

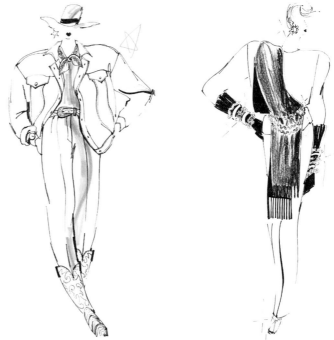

Keep the look tailored for professional polish.

Western gear—boots, belt, bandanna and hat—offers another option.

Extravagant accessories create evening allure.

A simple crew-neck sweater dress
never has to look the same way
twice. Tack on a white collar and
cuffs and pin on a faux flower for
one variation.

For a more sophisticated version,
try belting it at the waist, then
throwing an oblong scarf around
your head or throat.

A SIMPLE SWEATER DRESS: Many Frenchwomen live
in a little black . . . or blue . . . or sometimes red dress, cut like
a long sweater, which they can then belt at the waist or hips. It
has a crew- or turtleneck, or a little collar, like one found on a
Lacoste shirt. The dress is usually a simple and easy long-sleeved
or sleeveless shift (depending upon the season), never tight, but
definitely body conscious. It's great for those days when one
doesn't have the time or inclination to fuss, since it works well
on its own—*tout simple*—either unbelted or belted. It also looks
sensational with a big shawl thrown over one shoulder, with a
scarf knotted around the neck, with lots of pearls or just one
strand, under a vest or cardigan.

In winter, you'll find this dress in wool sweater knit and
jersey in practically every price range; for the summer, cotton
knit is the favored fabric, especially in an array of cool-looking
awning stripes.

The simple safari-styled shirtwaist is also standard dress: it
usually features epaulets at the shoulders, a small collar, button
front, belted waist and straight skirt. The customary accessories
are an Hermès scarf casually knotted over the collar and an ex-
pensive slim leather belt. In winter, look for this dress in wool
gabardine or silk; in summer, cotton gabardine or poplin.

A TRENCHCOAT: With a belt at the waist and epaulets at the shoulders, the classic beige English-style trenchcoat remains a French fashion constant. The only new touches are that today's model is worn a little longer, and may occasionally be black or navy instead of beige.

The French wear the trenchcoat belted—with the belt knotted, never buckled—or left open, with the belt brought back through the side loops, to be buckled in the center of the back.

It drizzles so often in Paris that a trenchcoat is a necessity, but again, quality counts. The French are willing to pay the price, but then they wear the coat for such a long time that it practically pays for itself!

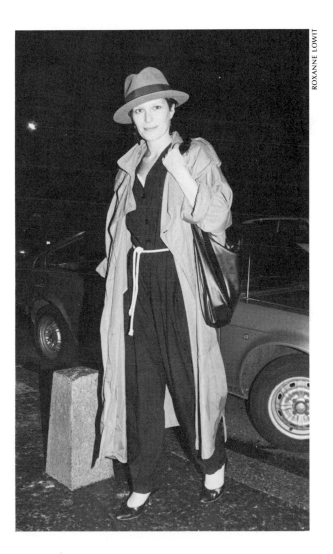

ROXANNE LOWIT

A chic way to face foul weather is a classic trenchcoat topped with a fedora.

A BLACK LEATHER BLOUSON: As soon as a chill wind begins blowing off the Seine, the black leather blousons come out in force. Usually styled like motorcycle or flight jackets, they vary in length from just below the waist, like the one pictured with jeans in the last chapter, to mid-hip to thigh. Top-of-the-line designers like Azzedine Alaïa and Claude Montana price their leathers very high, but blousons can be found in thrift shops as well as in a number of crammed Les Halles boutiques (L'Equipage being one of the best known). The very trendy prefer blousons with a "distressed" look.

As you might expect, their penchant for the unexpected comes through in the way Frenchwomen wear their blousons. They toss it over everything, from jeans, to miniskirts to a slinky black dress that dines at Maxim's.

A HEAVY COAT: This item used to be optional, since so many women made do with layers of sweaters under a blouson or trenchcoat, but in recent years colder Paris winters have made added warmth necessary. The styles Frenchwomen seem to most often select are a single- or double-breasted reefer, often cut like a man's overcoat, a nipped waist and full-skirted princess style, or the ubiquitous balmacaan in tweed or dark wool.

Winter coats are rarely worn without an oversized muffler or two, leather or knit gloves and a handbag slipped diagonally across the chest.

MARK BUGSZESTER

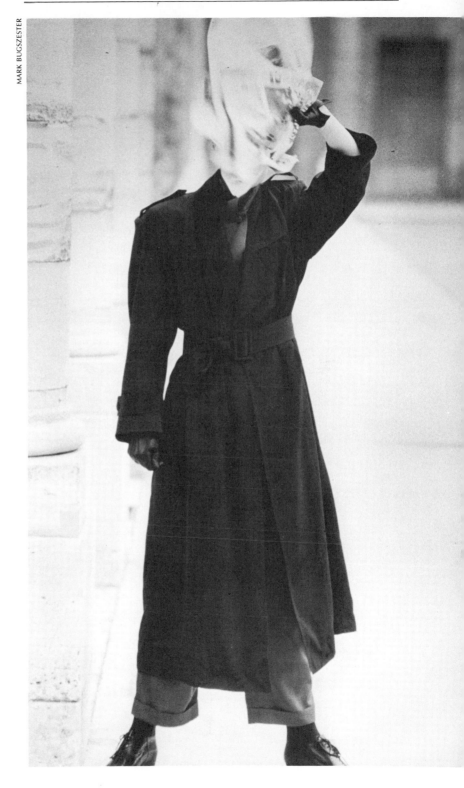

Like a trenchcoat . . . only warmer! This style works as well for casual weekends as it does during the work week.

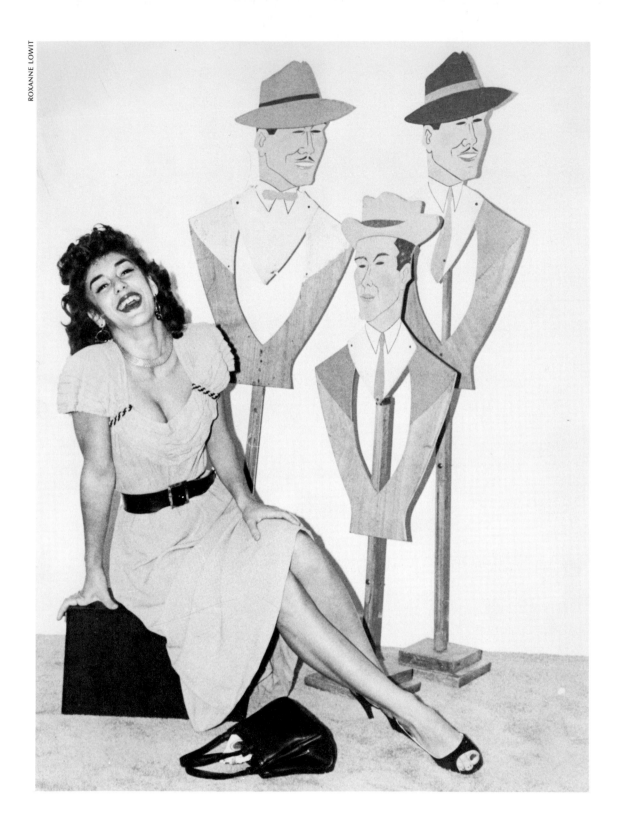

5

DRESS FOR A DIFFERENT SUCCESS

A little décolletage seems almost *de rigueur* to Frenchwomen. *Voilà!* A chic warm-weather dress that would be worn to the office, as well as out in the evening. Paris-based designer Vicky Tiel, renowned for her sexy, body-baring fashions, believes that dressing seductively comes naturally to the French, pointing out that "Puritanism never happened here. The French are totally at ease with their bodies. They believe if a body is beautiful, it should be displayed."

"I GET the feeling that American women dress for their jobs. Frenchwomen, however, even if they are career women, dress to please men." Although these are the words of fashion designer Thierry Mugler, he was voicing a theory that many French subscribe to. The "dress-for-success" syndrome so popular on our side of the Atlantic, which has every woman in the working world wearing the proper—and expected—garb for her profession, is a purely American phenomenon. Frenchwomen dress for a different success; one that we are finally beginning to turn our attention to. Office wear in America is becoming more feminine, more curvy. And nowhere is this more apparent than in the recent collections of several of our leading designers—Donna Karan foremost among them. The French, however, go quite a bit further.

"Proper attire" to a Frenchwoman always involves expressing rather than denying her sexuality: the desire to please is an integral and innate part of her persona. Christianne Celle, a freelance photo stylist in New York City, and a transplanted Parisian, remarks that "the way I dress depends in part on my boyfriend. I always adapt a little for the man I'm with. If I go out with a man who doesn't like what I have on, I get upset, but I don't wear it again with him. I don't change if I hate what he suggests, but I do listen to him. I like to please him. We Frenchwomen love to please our men . . ." Words are unnecessary. The Frenchwoman's desire to appeal is apparent in her glance, gestures and movements, as well as in the details of her dress. For no matter how proper her ensemble, she is still very much aware of her sexuality . . . and of how to make sure everyone else is too. Here are a few hints on how to add a touch of sex appeal to your look:

• High, high slim heels: They elongate the leg and make it look graceful. The shoe itself should be pretty and feminine—a classic pump or sling back during the day, strappy sandals for evening. And even when comfort is the issue, you would never see a suit or dress teamed with jogging shoes in the streets of Paris. Shoes meant for walking might be lower-heeled, but they are always attractive and stylish—flats with a bow, narrow loafers or espadrilles.

• Sheer black back-seamed stockings: They give a glamour-girl effect and draw attention to the legs. They also make heavier legs look thinner. Sheer black seamless stockings as well as black lacy pantyhose are also flattering.

ROXANNE LOWIT

Seamed stockings and high-heeled shoes add a seductive note to a simple skirt and jacket, while making legs look longer and slimmer.

Try a black feather boa tossed over your shoulders or looped loosely around your throat to soften the strictness of a black dress or evening suit.

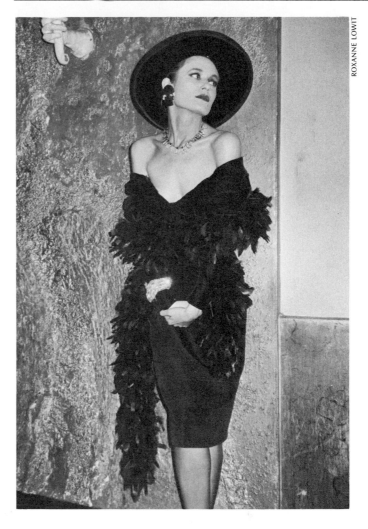

ROXANNE LOWIT

• A wide leather or cinch belt: It accentuates curves or even creates them. A wide belt looks wonderful with a simple sweater dress, a blouse and swingy skirt, or a long shirt and pants. Add new body-conscious appeal to your look and show off your shape by buckling the belt over a lightweight, loose-fitting blazer or short suit jacket.

• A jersey, suede or knit fanny wrap: This will draw attention to the hips and derriere. Your body will look especially sleek, slim and sexy if you wear a top with shoulder pads, then a narrow bottom, like a lean tunic over a long straight or pleated skirt wrapped low on the hips with a jersey sash, or a turtleneck knit dress, sashed in the same way.

• An unexpected touch at the throat: This can soften even the strictest suit. Try a fresh or faux flower, ropes of short pearls, an antique brooch, an extraordinary bar pin or a lace jabot. Avoid any top that looks too buttoned up, including the ubiquitous preppy little bow tie. Another French option: the silky, unbuttoned shirt, showing plenty of skin and the edge of a delicate camisole.

• A shapely skirt: A style that hugs the body and features a back slit to show off the legs, whether the length is long or short, is always sexy. When the skirt is straight, it should be snug but never skintight. When it is pleated, the pleats are usually stitched down to reveal the wearer's shape. An A-line or trumpet skirt is also narrow through the hips, with a flare at the hem. Because dirndl skirts are flattering to so few figures, the French rarely wear them.

• Close-fitting trousers: The best trouser styles, whether or not they are pleated, fit snugly over the hips and feature a tapered or straight leg. Team them with pantyhose and high-heeled pumps to elongate the leg and give the entire look a feminine air.

• A curvy jacket: It instantly femininizes the most formal or informal look. One jacket that is ideal is padded at the shoulders to

Twin or unmatched pins at the back waist of a jacket give it curve.

The waist-length bolero is one of the curvy little jacket styles that characterizes the French look.

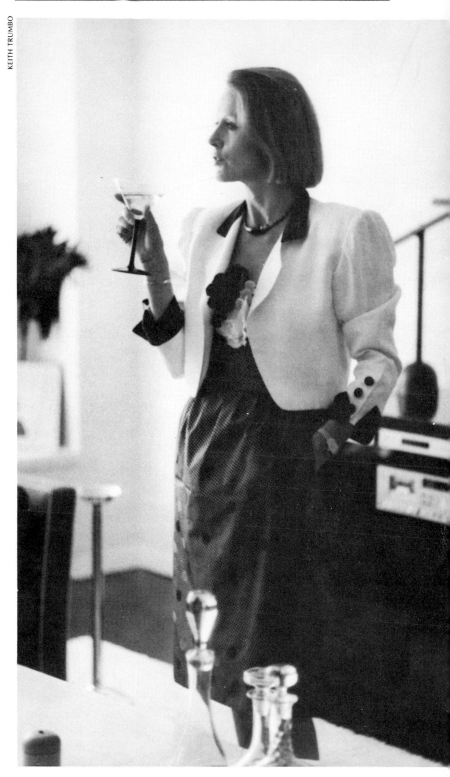

KEITH TRUMBO

make the hips look narrower, nipped in at the waist to define the body, then either peplumed or fitted, short (several inches below the waist) or longer (to the hips). A bolero style is also flattering. Either works in a stiff fabric for a more structured look, or a silk, double or sweater knit or jersey for a softer one. If you already own an unstructured jacket, here are a few suggestions for giving it shape:

* *Cinch it* with a wide or narrow belt or sash, or a handful of chains, Chanel-style.
* *Pin it* with a pair of brooches, matched or not. Gather the jacket at either side in the back, waist high, into a brooch.
* *Gather it* with a pair of sleeve garters—the ones with catches on both ends—used in the same way as brooches.

 Soften that structured blazer you already have in your closet in these ways:

* Pair it with a silky shirt or a lacy camisole.
* Wear it with a knit, silky or floaty skirt.
* Top it with a flowing shawl trailing over your shoulder.
* Team it with a lace hankie or a flower in the pocket.

• A sensational piece of signature jewelry: It could be a sterling link bracelet or that sweet gold locket that belonged to her grandmother, but whatever the article of jewelry to which she becomes attached—and it's usually something antique with a great deal of charm—the Frenchwoman makes it a signature: A very personal, natural and beguiling part of her look. Although she may change her other jewels and accessories at the drop of a hat, she remains constant to this particular piece. Take your cue from these chic Parisians and their signature jewels:

—An antique short silver necklace—prominent Paris-based interior designer Andrée Putman's favorite companion. Look at the myriad pictures taken of her and you'll notice she's never without it.
—A pair of eye-catching dangling earrings—one of designer Emmanuelle Khanh's constants.
—A Schiaparelli rhinestone bow pin—PR executive Frankie Rosenbloom does not feel dressed without it.
—Diamond stud earrings in the shape of tiny stars—they always adorn former TV producer Michèle Grunberg's ears.

DAY-INTO-EVENING DRESSING

A long workday that takes a Frenchwoman from her office directly out for the evening makes two different wardrobes—one for day, another for night—totally impractical. Wardrobe flexibility becomes a must in these situations, and she's grown adept at adding some evening allure to her day look simply by changing a few key details.

FIVE QUICK TIPS FOR A DAY-INTO-EVENING TRANSITION

* Substitute a silk or lace camisole for a shirt. Top it with your suit jacket. Or simply unbutton your shirt as low as you dare.
* Slip your suit jacket over bare skin, filling in the neckline with yards of pearls, or crystal or jet beads.
* Swap daytime shoes for evening sandals.
* Tie a ribbon in your hair or sweep it up into a sleek chignon.
* Spray on a little perfume and intensify your makeup.

THE BUSINESS SIDE OF SEX APPEAL

France has long been famous for its emphasis on the seductive side of fashion. French designers in every price range truly take a woman's body into consideration, and create styles that celebrate the female form. Here's a brief rundown of several key creators, and what they are best known for:

• AZZEDINE ALAÏA. Sexier, more form-fitting clothes than his do not exist. A master of knits and butter-soft leathers that fit like a glove, Alaïa believes in "doing all he can to embellish a woman's body."

• THIERRY MUGLER is another designer celebrated for his voluptuous, *femme fatale* fashions. "What I do is neither moral nor intellectual," he says. "It's physical. After all, I was the one who first discovered the body."

• SONIA RYKIEL has a style that has remained instantly recognizable and consistently curve-caressing through the years: long, lean lines and soft, clinging knits that show off a woman's hips and backside.

• EMANUEL UNGARO is master of the sensuous slide of a dress, usually in a draped or shirred jersey that is naughty yet elegant. "If I had to define my style or my creative technique, I would say that it is basically sensual. In every sense of the word. And for all senses."

• YVES SAINT LAURENT's waists are nipped, silhouettes sleek, and suits, the height of sexy chic. His designs have many moods, but every one of them emphasizes the female form.

• HUBERT DE GIVENCHY, especially in recent collections, creates clothes that are discreet yet sensual. Both day and evening looks are shaped, sexy and sometimes skintight, with an extravagant but tasteful allure.

• CHRISTIAN LACROIX draws inspiration from many sources to arrive at witty, whimsical silhouettes that have created the biggest splash in the Paris couture in years. He brought back the bustle and the cinched waist, shows lots of leg and has never been accused of keeping anything under wraps.

• KARL LAGERFELD utilizes leather and chains, curvy little suits and glamour-girl evening dresses to give Chanel designs a fresh and witty sensuality that is irresistible to Parisian women. If they cannot afford an original design, they simply use the creativity they are known for to reinterpret the look more affordably.

• EMMANUELLE KHAHN's clothes have always idealized the female form: shoulders are extended and waists cinched so that the bust is played up and hips narrowed.

• CHANTAL THOMASS creates clothing, yes, but it is her sexy lingerie that chic Parisians are having difficulty keeping under cover . . . it shows up every once in a while on its own.

LINGERIE

The late, great couturier Christian Dior once said, "Without foundation, there can be no fashion," a belief that Frenchwomen wholeheartedly share. Lingerie not only shapes their bodies, it shapes their behavior, too. It's one of their secret weapons. Because underwear is usually the silkiest, most frivolous and feminine part of their wardrobes, it helps them to feel sexy . . . and act it! In fact, for many women, wearing the right underthings—those that help them feel flirty and feminine—may be more important than owning the right skirt or shirt. Beautiful lingerie creates the right mood for the Frenchwoman at every hour of the day and night. The owners of two of the most luxurious lingerie shops in Paris—Les Folies d'Elodie and Les Nuits d'Elodie—concur. They are seeing more and more business women buying extravagant underthings to wear to the office, perhaps because they don't want to lose touch with their femininity while working in a man's world.

Chantal Thomass, a leading clothing designer also known for her exquisite lingerie, explains that the indispensable underthings are garter belts, body suits, camisole and panties, and bras. But the exact items the wearer chooses are dictated by aesthetics rather than by function. Pantyhose might be more practical, but a garter belt is prettier, more sensual to put on and wear, so it's a favorite. The Frenchwoman is at ease with her body, and believes that intimate garments should have a texture that echoes the softness they cover. Silk and satin are favored, as are silk and cotton blends, very fine cotton and filmy lace. She is so unselfconscious about both her body and what's on—or off—it, that it is not uncommon to see her in a sheer blouse over bare skin . . . or a lace bra. And speaking of lace, she often lets it peek out to add a sexy note, even to a sober business suit.

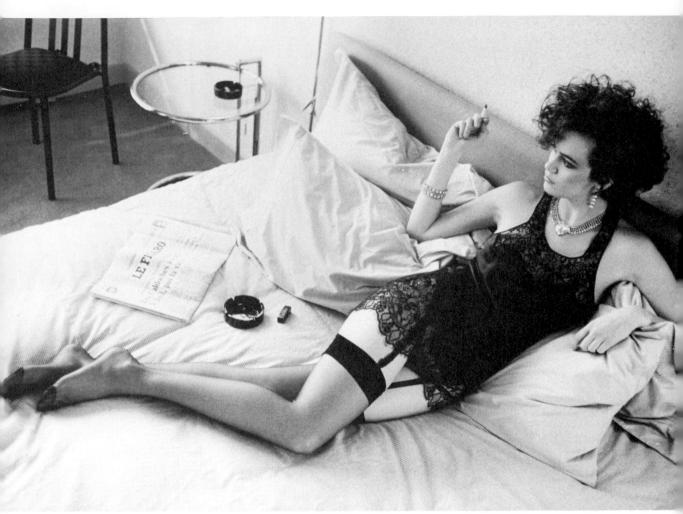

KEITH TRUMBO. COURTESY COSMOPOLITAN.

Underneath her crisp cotton shirt
and plaid pleated skirt, don't be
surprised if the average
Frenchwoman is wearing lingerie
like this. And the garter belt is
usually her highest priority!

**FIVE WAYS
TO SHOW A
LITTLE LACE**

1. Sexy black, white or ecru stockings or pantyhose.
2. The lacy edge of a black slip showing at the kick pleat of a skirt when you walk.
3. The lace trim of a camisole revealed at your décolletage.
4. A lace bodysuit under a sheer blouse—black under black, white under white.
5. A black lace bra under a suit jacket—for evening only.

Often, however, lingerie is too beautiful—and too expensive—to keep under wraps. So the French flaunt it: a silk bathrobe or kimono doubles as an evening wrap, silk pajamas go dancing as a pair, or broken up: the silk pajama top teamed with a lace skirt, pajama pants with a cashmere sweater or even a T-shirt. And silk or satin nightgowns, especially when they're cut like glamour-girl dresses of the forties, are frequently worn in the evening.

**TWO
FRENCHWOMEN
AND THEIR
LINGERIE
SECRETS**

• A silk camisole and panties, often a garter belt as well, are the underthings designer Chantal Thomass wears daily. Then, although she explains that she rarely wears one, she'll occasionally put on a bra—"for beauty, not function."
• A garter belt is PR executive Frankie Rosenbloom's passion. She feels that although putting it on may take time—a commodity she and other busy Frenchwomen don't have much of—it gives her the feeling she's taking more of an interest in herself.

FRAGRANCE

While lingerie is one secret weapon, perfume is another. French-women automatically link it to both seduction and fashion, and use it to create the right mood and atmosphere. Fragrance is integral to their sense of style and well-being. They select scents that are subtle and suggestive, apply them sparingly and then reapply them often throughout the day. Although her particular perfume is never the first thing you notice about a Frenchwoman, it is usually the last memory, lingering in the air long after she's gone.

SIGNATURE SCENTS

Just as they stay true to their style and bank on the classics, Frenchwomen are faithful to their fragrance and use their personal scent as a signature, one with which they are associated and by which they are remembered. They do, however, experiment, and sometimes become so carried away by a new perfume that they fall captive to it and make a change. But they often stay with the same one . . . or two . . . for life. To quote Sonia Rykiel: "A woman must always have a base perfume—her scent. Then she can add other scents to this base, just like she would add a belt to an outfit."

HOW FRENCH-WOMEN WEAR FRAGRANCE

Fragrance may be the first thing a Freenchwoman applies, or her finishing touch, but it's never overlooked. Couturier Hubert de Givenchy calls it "the necessary part of a woman's attire," while Vicky Tiel remarks, "Fragrance is the ultimate turn on . . . and probably more important to the Frenchwomen I know than clothes are."

Understatement, however, is a guiding principle in French life, and even though fragrance plays such a significant role, it is

never overdone. Frenchwomen never drench themselves with perfume. They apply it in layers, so that the scent is gently released with their natural body movements. And they stick to the same scent for every form of fragrance used.

They begin with scented soap and bubble bath or bath oil, followed by matching body lotion. They finish with *eau de toilette* for day, or perfume for night. They carry a small flacon in their handbags to refresh their fragrance every few hours.

Each fragrance strength has its place. *Cologne,* which is the lightest fragrance form, and popular in America, is very rarely used by Frenchwomen. They prefer *eau de toilette,* which is stronger. Because it contains a higher concentration of essential oils, it is longer lasting. At night, they usually switch to *perfume,* the most concentrated form of fragrance and the longest lasting —it lingers on the skin for about six hours.

WHERE THEY WEAR FRAGRANCE

Both *eau de toilette* and perfume are applied at the pulse points so that the body's heat will help bring out the fragrance: behind the knees, between the thighs, the décolletage, throat, base of the throat, the insides of the wrists, elbows and behind the ears.

SHOPPING FOR SCENT

The French know that because fragrance is affected by body chemistry a particular scent will not smell the same on any two people. They also know that scent in the bottle does not smell the same as it does on the skin, and that it must be tried on and worn for a while before making a decision about buying it. When you set out to sample the new scents, try a few French techniques:

* Try on a maximum of three scents at one session: the nose cannot differentiate between more.

* Shop for scent late in the day, when the sense of smell is sharpest.

* Apply fragrance to palms or insides of elbows, where perspiration and heat help to release it.

* Wait at least ten minutes before checking the scent to give it time to develop.

LOOKS FRENCH-MEN LOVE

A discerning taste seems to be part of every French person's cultural heritage. And just as Frenchwomen enjoy a reputation for tremendous chic, Frenchmen are renowned as true connoisseurs of women and beauty. They pride themselves on their sense of aesthetics, in fashion as well as in all art forms. In fact, they tend to be as interested and fashion-conscious as French females, and appreciate the effort Frenchwomen take to put originality into their ensemble. While tastes may vary somewhat from individual to individual, Frenchmen like women to look *soignée* and seductive, whether they are dressed up or down.

ROXANNE LOWIT

Businesslike, but so seductive. This look certainly means business, but the chaste white ruffle-collared blouse, tight Capri pants and heels soften the severity of the man-tailored, tiny-checked blazer. To this, trend-setter and transplanted Parisian Marian McElvoy (pictured with her husband, designer Dik Brandesma) adds polka-dotted gloves and a giant dotted pocket square for a bit of Gallic-inspired whimsy.

ROXANNE LOWIT

Flirty and fitted. Frenchmen appreciate fashions that play up the female form, like this ultrafeminine, curvy little office-to-evening suit, with its short jacket and ruffle-edged straight skirt. The accents also add to its overall allure: short gloves, a giant ring and hoop earrings, stiletto heels and a hatbox handbag.

ROXANNE LOWIT

Chic and curvy. The smart suit, whether traditional or trendy, is a French favorite. Designer Myrène de Prémonville (pictured with Gilles Dewavrin), wears one of her head-turning designs. The boldly striped jacket, with its nipped waist and peplum back worn over a skinny short white skirt, accentuates the form. Sexy black heels, hosiery and laced-up gloves are other touches men appreciate.

ROXANNE LOWIT

Glamour Girl. Men like their women glamorous for festive evenings in outfits that play up the body, like this long stretch of wrapped jersey. They also appreciate the effect of a total look —when hair and makeup complement the outfit. In this case, Michelle uses her long hair as the ultimate accessory—she braids it, binds it with a scarf and lets the ends float free.

ROXANNE LOWIT

Smart, never stuffy. Paloma Picasso wears a look that brings raves because of its sheer simplicity: a wear-for-years braid-trimmed suit and sensuously draped shirt, her only jewelry a pair of interesting earrings.

83

ROXANNE LOWIT

Country girl. Frenchmen adore equally a casual country-girl look that is both underdressed and under-madeup . . . based on easy jeans, a classic T-shirt and minimal accessories: a studded belt, cowboy boots, slim gold hoop earrings, an armful of rubber bangle bracelets plus the popular steel and gold Rolex watch.

THAT CERTAIN STYLE— FOUR MEN DISCUSS THE DIFFERENCES

Say "French style" and men think more about demeanor than dress . . . or so it would seem from the opinions of the following four men—two American, two French—who have all lived extensively on both sides on the Atlantic.

"I think the differences are a result of education and background. The Frenchwoman sees men in a different way than the American does . . . so she acts differently. She tries to charm men . . . to please them. She's very feminine and makes herself sexually appealing. And that's apparent in the way she puts her fashion look together."

—Arnaud Bamberger, French jewelry executive

"Frenchwomen are very romantic. They flirt much more . . . and are much less business oriented than Americans. They don't discuss their career the minute you meet them . . . it's only after knowing them a while that you find out what they do, or how involved they are in their careers."

—Bertrand de Vort, French movie distributor

"I think that French men and women are basically more comfortable together than American men and women, so the Frenchwoman conceives her role differently than an American does. She's had less indentity crises. She knows her physical assets and liabilities and doesn't submit blindly to fashion. She never varies from what looks best on her. She has a kind of pleasant self-assurance and self-confidence without the grinding attitude."

—John Vinocur, American newspaper editor living in Paris

"Seduction is part of the nature of a relationship in France. It's a game. Men and women look at each other in the street, not to pick each other up, but to acknowledge their sexuality."

—Henri Lange, American movie producer living in Paris

6

PERSONALIZE WHATEVER YOU PUT ON

What a difference accessories make! While the clothing is relatively classic, the outlook is anything but, because of the dramatic, oversized, sculptural jewelry.

THE French look consists of a variety of styles but a single spirit—self-expression. And nowhere is it more evident than in a Frenchwoman's accessories, in the details that finish, but more often fashion, the entire outfit. Frenchwomen wear clever accessories, which they change at whim to instantly update any old thing and give it the stamp of originality. They seem to have an implicit understanding of the little touches needed to achieve just the effect they want.

It could be the twist of a scarf or the turn of a belt that adds the punch—and personality—to a plain sweater and pleated skirt. It could be a colorful silk camellia pinned at the throat; a pin shaped like a graceful hand with its fingernails painted red; ropes upon ropes of gold chains; a wide golden cuff on each wrist or an armful of silver bangles; even a pair of rhinestone earrings in the shape of the Eiffel Tower. Though they can be outrageous, Frenchwomen also seem to know when less will make more of a splash. And when they don't know—because there are times when even they are uncertain about what will work and what won't—they bluff. They improvise and experiment.

Andrée Putman sums up the French approach to accessorization this way: "I think that Frenchwomen have a mysterious

need to be themselves by adding their little accents: the jewel, the makeup, the haircut. These add the 'vinaigrette,' or 'chic,' that is French. I've noticed that when American women wear French clothes, they often wear them with too much respect and obedience . . . without the vinaigrette. Style is invention. You cannot just follow rules. You have to somehow go against them."

This celebrated vinaigrette is as much a tasteful blend of specific attributes as a mix of specific items . . . with the proportions varying according to your personality. So, when you're adding the "dressing" to your look, don't underestimate the power of these vital ingredients!

THE VITAL INGREDIENTS FOR VINAIGRETTE

* Spontaneity—The most successful look appears to have been achieved effortlessly, no matter how much planning might have been involved. You'll notice that the scarf is casually rather than tortuously knotted. Belts, watches or chains seem artfully arranged. The total effect is spontaneous; the French never want to look as if they're trying, much less trying too hard. One way you can go about achieving an effortless chic is to experiment with different accessories, using them in unexpected ways in the privacy of your room until you arrive at a few different looks that feel comfortable and appropriate.

* Surprise—The French adore unexpected touches they can wear with a wink—and a smile. Be on the alert for those details that take a look out of the ordinary: two or three watches at a time, instead of just one; a Mickey Mouse watch with a business suit; a pair of colorful pantyhose or socks to brighten a somber ensemble; a handbag in the shape of a heart; a man's watch on a fob suspended from a belt.

* Imperfection—The French studiously avoid matching accessories—coordinating bracelets, earrings and necklaces, for example—because they look too pat, too perfect, too planned. In fact, a Frenchwoman more often than not deliberately pulls together disparate pieces and makes them work. She strives for harmony rather than perfection, and does so by mixing old and new jewelry in different finishes, heaps of pearls in different colors, a lizard belt with velvet shoes and a leather bag, or a new Hermès bag with flea-market gloves.

* Discardability—Charm and style take precedence over price when selecting accessories. Generally, Frenchwomen spend little on them, so that they can buy lots. In fact, they firmly believe that even the best and costliest accessories are ephemeral and should change often, according to mood, occasion, season, the trends of the times and the vagaries of taste. So, except for a few classics that may have been handed down from their grandmothers, the life-span of any accessory they own is limited.

* Contradiction—The woman who might wear a simple sheath with a pair of pearl stud earrings one day might wear everything she finds in her accessory drawer the very same evening: the French adore contradictions. They see fashion as a game, and part of the fun is avoiding any kind of routine.

* Suitability—The French sense of protocol is deeply engrained, however, so each look has to work for the occasion in question. But when they're in doubt about suitability, Frenchwomen will play it safe and underaccessorize.

* Adaptability—The French realize that as times change, fashion trends do, too. As design luminary Karl Lagerfeld explains: "The notion of what is chic and elegant is as changing as fashion itself. . . . The things you hate one day, you are very likely to love another." To be truly adaptable you must be prepared to accessorize with the times.

* Confidence—Whether it is their cultural heritage or sense of what's "now" that gives them their fashion confidence, Frenchwomen are adept enough with accessories to turn even a handicap into a fashion asset. They'll envelop a sprained wrist in a wrapped-and-bowed designer scarf, support a broken arm with a fabulous shawl as a sling, or follow the lead of designer Emmanuelle Khanh, who created an array of bold, beautiful eyeglass frames to encircle her prescription lenses, thus transforming a necessity into a must-have accessory.

THE ELEMENTS

Now that you have a better notion of the general effects Frenchwomen aim for with accessories, let's take a look at the individual elements that will create them. To simplify your choices, they are grouped by category. Then the "constants" within each category—those enduring essentials Frenchwomen consistently

count on to finish a look—are clearly listed so that you can add the ones that work for your life-style to your wardrobe. You may also want to pick up a few extras that are in fashion at this very moment (the ones that change too quickly to be included in a book) to arrive at an allure that is both timeless *and* trendy . . . the keynote of French chic!

Let's start with a category that's very important to style—chic Frenchwomen always want to put their best foot forward.

SHOES. The French put their francs into shoes, believing—and rightly—that expensive shoes upgrade an entire outfit. For this reason, they usually own just a few high-quality pairs that work color-wise with almost everything they own. Favorite colors are the neutrals, but sometimes they will count on brights, like red, purple or royal blue, to perk up an entire outfit. The cut of the shoe—it has to complement their feet and legs as well as their ensemble—counts as much as comfort.

When shopping, sacrifice quantity for quality and buy the best-grade shoes and boots that you can afford, in neutral shades. Black is probably the ideal first choice, in leather, lizard, suede or patent leather; the latter particularly will work year-round. If your wardrobe is built around browns and beiges, consider shoes in an attractive shade of luggage or taupe. Burgundy is another neutral that works with many colors. In warmer weather, pale taupes and beiges are smarter than white, except at the beach. For a change of pace, however, follow the French lead and try a bright shoe for that sought-after note of surprise, especially when you're wearing all black or all white.

Some favorite French styles that adapt well to American wardrobes are:

Best-dressed classics: the Chanel sling-back shoe and chain-handled handbag.

* *The Chanel-style pump or sling back.* An all-time, best-dressed classic, these are very flattering and feminine, whether on a mid-high heel, a low one or a flat. They are usually available in leather with a patent toe in all of the neutrals, and look wonderful with all but the sportiest outfits.

* *Classic pump or flat.* Look for these in a range of heel heights, colors and materials. Those with a low-cut top that allows most of the instep to show tend to be most flattering, since this cut elongates the leg. This style is ideal for all but the most casual ensembles.

* *Loafers.* These are usually flat, or can have a small wide heel, but should never be clunky or heavy-looking. Wear them with tailored pants or jeans and your most casual sweaters and skirts.

* *Ballerina flats.* These are a popular warm-weather shoe with long skirts or trousers and T-shirts. They are extraordinarily feminine and flattering, yet a little too casual for most offices. Aside from black and white, they are prettiest in bright or pastel colors.

* *Espadrilles.* A warm-weather classic, particularly in the South of France, espadrilles are slightly more casual than ballerina flats. Best worn with beachwear, as well as simple summer shifts and shorts.

* *Boots.* A good pair of boots in black or a burnished brown leather or suede to wear in winter can look fashionable for years. Stick with classic styles that are knee high and cut to gently hug the calf on a flat or low-to-medium heel, or low enough (several inches above the ankle) to tuck trousers into, or to pair with longer skirts and textured pantyhose. Another French favorite is the cowboy boot, but it has to be hand-tooled and beautifully weathered. These may not work for your job or life-style, but if they do, they can add a singularly original note.

HANDBAGS. Frenchwomen generally make do with a single well-made handbag for winter, and another for summer, which take them through both the day and evening. The quality is high, and so, generally, is the price. But even when it is a bargain, it looks expensive. However, this bag wears well for years and makes the owner look and feel wealthy, so it's an expenditure they consider very worthwhile. Both the style and shade are neutral. Size varies according to the wearer's needs, but it's generally large enough to accommodate daily essentials.

When you've built your wardrobe around one or two colors, it will not be difficult to find a handbag shade that will work with everything. While bags and shoes do not have to match, they should complement each other. With black shoes and basically black clothes, carry a bag in black or burgundy, luggage or even deep hunter green; with brown shoes, stick to tones of brown or taupe; with burgundy shoes, a black or burgundy bag; with navy, a navy, a black patent, a brown or a burgundy bag, depending upon your wardrobe.

Favorite French styles include:
* *The Kelly Bag:* This is the bag Hermès created for Grace Kelly. It looks like a satchel and most Frenchwomen wear it with a shoulder strap, slung across the chest rather than over the shoulder. The real "Kelly" is an expensive investment, although it will last and last, and has been known to be handed down from mother to daughter. But there are many well-made copies around.
* *The "Chanel" Bag:* Quilted leather on a chain handle, this chic bag has been widely copied in all sizes.
* *The Camera-Case Bag:* This is a shoulder bag with a classic squarish shape and top zipper, in a practical size. It works when you do, yet is casual enough for weekends.
* *The Saddlebag:* A larger bag for those who always have lots to carry, this style is popular in leather, canvas and a combination of the two.
* *The Evening Bag:* This is a "formal occasion only" bag. It's very small, in silk, satin, velvet or dressy leather, or it may be an antique beaded model in a pouch, clutch or quilted, chain-handled style. Colors are usually black or metallic.

BELTS. Everyone owns at least one handsome, classic brown or black belt in fine leather, lizard, suede, alligator or crocodile. The Chanel gold chain belt is also a mainstay. In fact, a common trick for dressing up a skirt and silk shirt is to simply switch belts: wear the leather by day, the chain at night.

A wide cinch belt, a tooled cowboy belt, a beaded belt that says "Florida," a black velvet ribbon, narrow leather strips that sit on the hip, even a length of black rubber tubing may also be included in a Frenchwoman's belt repertoire. The point to remember when you are choosing a belt is to keep your eyes open for anything interesting that might add another dimension to the fashions in your closet.

HOSIERY. Frenchwomen generally shy away from wildly patterned or textured hosiery, favoring instead sheer beige, black or gray stockings or pantyhose. There are exceptions, however, like a vivid color with an all-black ensemble. In winter, they often switch to heavier-textured ribbed or opaque hose, in black or cream, navy or camel. For evening, dotted, lacy or seamed hose are popular. They have a special fondness for little white anklets —with jeans and loafers, with long skirts and ballerina flats or heels. With trousers, they like a ribbed or argyle sock.

NECKWEAR. Every chic Frenchwoman owns an abundance of attractive neckwear. A large patterned silk square is a must to wear in a multitude of ways, some of which you've already seen earlier in this book, some of which follow later in this chapter, but smaller squares (to tuck in a pocket, or simply knot around the neck) and long oblongs (to tie in the hair, around the throat or around the waist) are also essential.

Fine cashmere or wool mufflers become more than cold-weather necessities in France. They are snapped up in a range of colors to wear tied, bowed, tucked into a sweater, festooned with

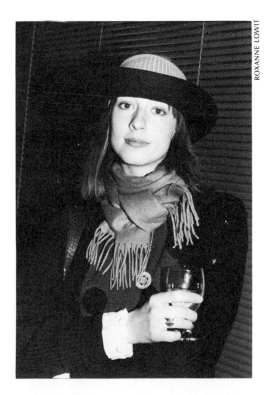

ROXANNE LOWIT

The versatile fringed cashmere muffler worn double-wrapped around the throat.

93

pins, even draped two or three at a time. Very long ones are also tossed over the shoulder, shawl-style.

Oversized scarves, shawls, even small blankets are also favorite wardrobe pickups. Select them in silk, challis, wool and cashmere, and drape them *à la française*—over one shoulder with ends flowing, across the throat with ends trailing behind your back, or over both shoulders with ends crossed at the throat and thrown from front to back.

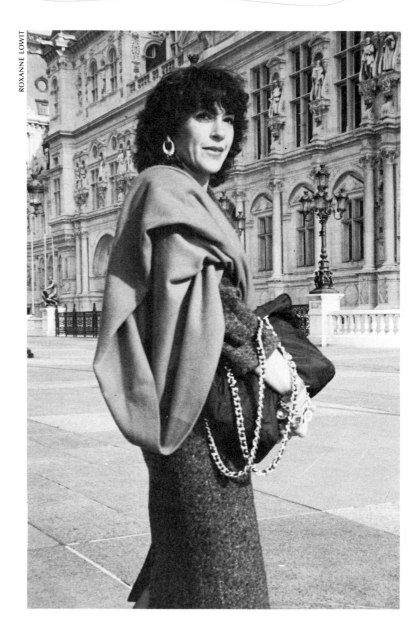

ROXANNE LOWIT

The giant shawl can be draped across the shoulder or simply tossed over it with ends dangling. Either way, it adds both warmth and chic to a suit.

If you love the look of men's ties, collect old and new ones in different widths and patterns. Then accessorize them with tie tacks or brooches, long necklaces or stickpins. Loop a tie around your neck, then tack a flower to your lapel. The French adore the femininity of flowers. Sonia Rykiel and Chanel always show loads of faux blossoms in their collections. A spray of flowers tucked into a jacket pocket is one new way to wear them.

EYEWEAR. Don't forget about glasses, especially sunglasses, when you finish your look. They have always been highly valued in France, whether or not they were actually needed for seeing. The American Ray Bans are particularly coveted, although France is noted for innovative eyeglass frames. Those of Alain Mikli and of Emmanuelle Khanh, for example, are popular on both sides of the Atlantic. Treat glasses as you would any other accessory, and choose the frames and shaded lenses that work best with your skin tone, hair color and fashion image.

HEADGEAR AND GLOVES. Most Frenchwomen choose hair ornaments—all manner of bows, combs and headbands—over hats, aside from little berets, wool knit or fur cloches and hunting caps they wear to keep out the cold when January winds blow. However, you will occasionally see a slouchy man's fedora or porkpie hat, a wide-brimmed felt or straw, or a tiny, tulled, forties-looking cocktail hat worn just for fun by the few women who look sensational in them, who have the confidence *and* the right coiffure—one that's simple and close to the head. If hats become you, go right ahead. When they work, there's nothing like them for adding panache to an outfit.

Gloves are worn not only to keep hands warm in winter but to add a finishing note, and range from the kicky to the practical. The same woman might wear a pair of short black kidskin gloves with her black suit, or she might switch off with a pair of checked fabric gloves or long, brightly colored jersey ones that she bunches at the wrist. A few other favorites include:

* *Leather or pigskin driving gloves.* This sporty style looks sensational with a tweed or blue blazer and jeans or a skirt. When you take them off, wear gloves in your breast pocket, like a hankie.

* *Wool knit or cashmere gloves.* A favorite winter glove, ideal with heavy coats and layers of sweaters. When the knit is thin enough, they are worn layered.

The bowler hat—a fun finish!

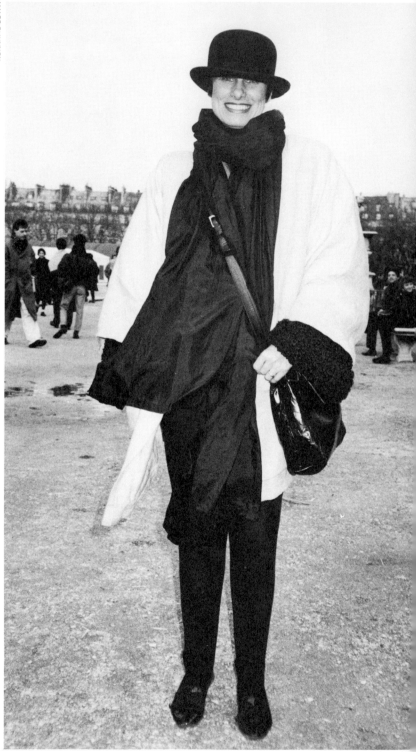

ROXANNE LOWIT

* *Elbow-length evening gloves.* Worn with arm-baring evening dresses, and made of satin or the finest kid, these gloves fit like a second skin. Usually in black, they provide a perfect backdrop for rings and bracelets, which are worn over them.

JEWELRY. Depending upon the look they wish to project, Frenchwomen feel as comfortable wearing lots of jewelry as with none at all. They enjoy mixing the real and fake, the old and new and silver and gold to achieve an effect that is true to their personal style. When medals were making fashion news, for example, the Preppie wore one on a lapel, while the Trendy covered an entire lapel; the Aristocrat chose one already in the family and the Sophisticate bought a designer medallion.

The "secret" here is obvious—wear jewelry in keeping with your overall look. When in doubt, keep it simple. And when you can afford it, keep it real. Most Frenchwomen own at least one piece of "real" gold. And that means 18-carat gold, which is yellower than the 14-carat popular in America. Small gold hoop earrings and short gold chains worn in multiples are classics that go with everything. Most Frenchwomen also own an expensive watch. One style that has endured is the stainless steel and gold Rolex.

The choice of jewelry is highly personal, since it depends so much on factors like your budget, job, wardrobe and personality. One way to accessorize jewelry the way the French do is to aim for a specific effect:

—*Theme your jewelry/accessories:* Whether it's all Art Deco, Nouveau, or Navaho (turquoise-and-silver Indian jewelry, a cowboy

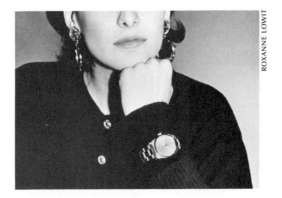

A typical Rolex stainless steel and gold watch.

ROXANNE LOWIT

ROXANNE LOWIT

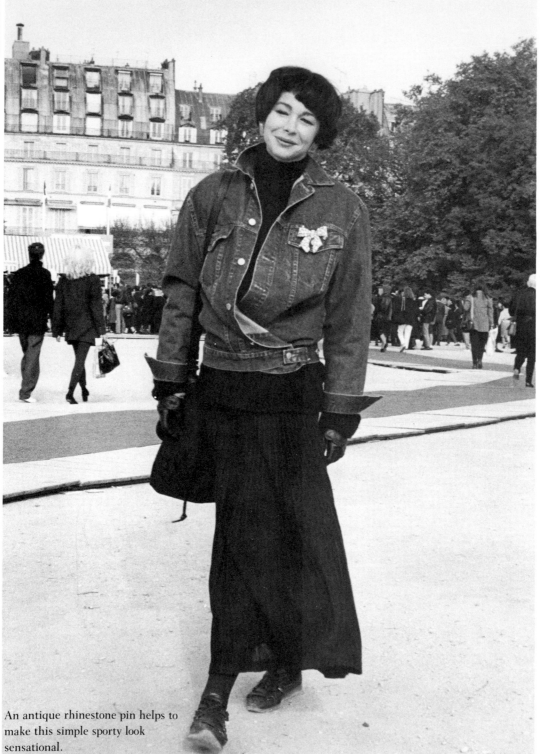

An antique rhinestone pin helps to
make this simple sporty look
sensational.

hat, a tooled leather belt, boots), stick with details that have the same feel.

—*Choose a signature category:* Be an earring person, or begin with brooches. The point is to zero in on a category you love and start collecting interesting pieces.

—*Let one fabulous piece carry your look:* Wear only one piece of jewelry, but make it attention-grabbing: a giant brooch, a cluster of charms on a bracelet, an antique chatelaine.

—*Concentrate on lots of little things:* Try several slim gold chains around your throat plus a strand of pearls, tiny earrings, numerous bracelets, an array of rings.

FORTY-EIGHT UNEXPECTED ACCESSORY IDEAS

Now that you know what to look for, here are forty-eight great ways to work with what you've got:

1. A multitude of ties at a time: instead of just one, pile them on. Vary the widths and placement of knots . . . mix in chains or pearls, adorn with pins or clips.

2. Pull back your hair: let the ends of your tie trail down your back.

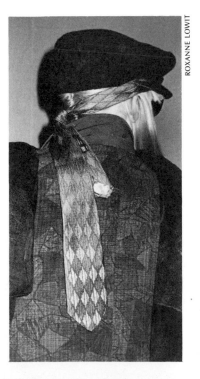

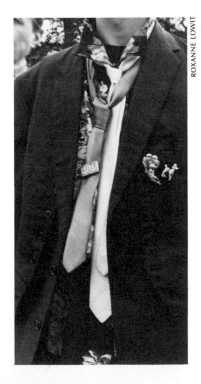

LEFT:
Another way to add interest to a chignon or ponytail.

RIGHT:
Why wear one tie when many look so interesting?

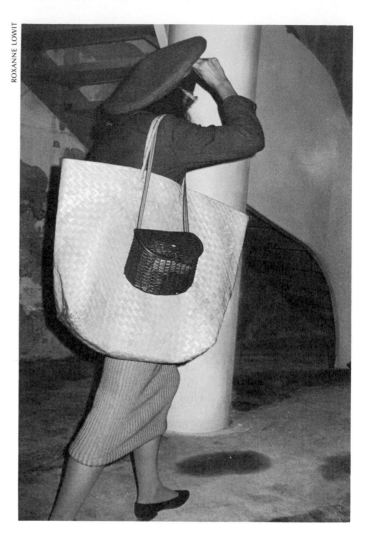

ROXANNE LOWIT

Team handbags in different sizes.

3. Handbags two at a time: try two small shoulder bags, Chanel-style, or a giant tote teamed with a teeny version.

4. Layered socks: layer several lightweight pairs on at a time, bunching the cuffs at different heights.

5. Layered gloves: ditto for gloves, alternating lengths so all are in view.

6. The charm of an ankle bracelet *over* socks: for a fun, sporty look.

7. A big, glitzy brooch to back an evening dress: highlight super shoulders, the sexy curve of your spine with jewelry that draws attention to them.

8. The toss of a towel: try one over your shoulder as a totally

A dainty ankle bracelet feminizes *any* look.

original substitute for a shawl. A lap blanket, an antique table-cloth or bureau runner also work well.

9. Twin pins or sweater guards: wear them at either side of a boxy jacket to nip in waist and give a fresh new fitted form.

10. Bow bracelet: tie a slim ribbon around your wrist in a bow and slip it in with a bunch of chain bracelets.

11. A watch on a belt: suspend a pocket watch on a chain from a belt at your waist or buckle a wristwatch over your belt for a similar effect.

12. The more belts the merrier: wrap an array of skinny leather and chain belts around your waist or hips. Or wear one belt that *looks* like two!

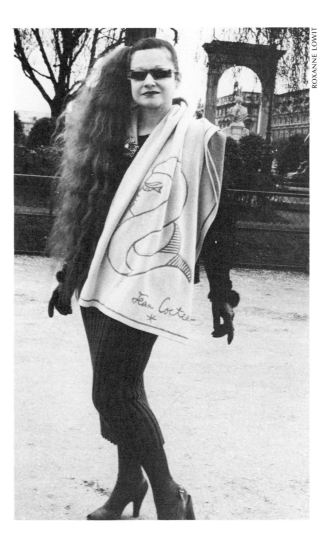

You may not dare wear a towel, but it does provide inspiration.

The French often tie an Hermès ribbon around their wrists, but any ribbon will do.

13. Pearls in new places #1: ropes of pearls across your chest, bandolier-style. They look especially effective at night, with a little black sweater dress, or pants and a pullover.

14. Pearls in new places #2: a long strand draped over your shoulders and tied in place with the straps of an evening dress.

15. Pearls in new places #3: an extra-long strand around your waist, wrapped around a belt loop with ends tucked into your pocket, watch-fob style.

Try ropes of pearls draped across your chest over a silk shirt.

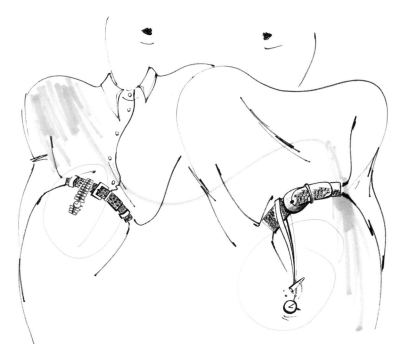

Accent your waist with wristwatch or pocket watch on a strap or chain looped over your belt.

Try three or more strands of pearls around your neck instead of only one.

ROXANNE LOWIT

For plenty of waist interest, try a wide belt topped with a narrow one, like this chain belt accented with coins.

16. Pearls in new places #4: at least three strands around y[
neck, but worn *inside* your neckline so that strands peek out at
sides only.
17. Short socks with high heels: try this combination with a
mid-length skirt or a pair of Capri or cropped pants.
18. A pair of lacy pantyhose: dress up the simplest skirt and top.
19. Sunglasses: Frenchwomen wear them at night to turn heads
and add intrigue to an evening look.

Drape a long strand of pearls over your shoulders and tie it in place.

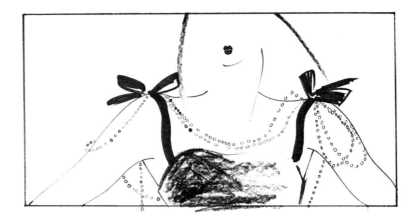

Try a long strand of pearls around your waist and tucked into the pocket of your pants.

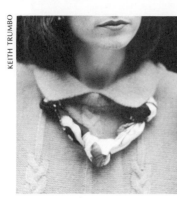

The rope-knotted scarf.

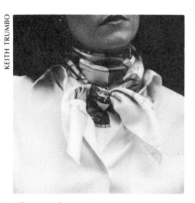

The scarf, ascot-knotted.

20. Scarf trick #1: belt your scarf around your waist. Fold a silk square on the diagonal to form a long strip, then pull it through belt loops and knot it on one side.

21. Scarf trick #2: rope-knotted. Prepare your scarf exactly as you did above, knotting it every few inches. Tie it around your neck, knotted in back.

22. Scarf trick #3: end-knotted. Fold scarf in half diagonally and throw over your shoulders, knotting ends only.

23. Scarf trick #4: ascot-knotted. Fold scarf in half diagonally and center the point at your throat. Cross ends behind your neck, bringing them to the front and tying them into a square knot. Drape scarf in folds, tucking the point inside your shirt and pulling the ends out.

24. Scarf trick #5: treat your scarf like a man's tie. Fold it diagonally until it is in one long strip. Put it around your neck with one end longer than the other. Cross the long end under the

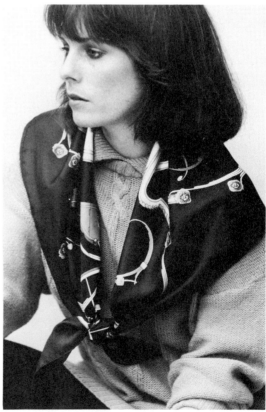

The end-knotted scarf.

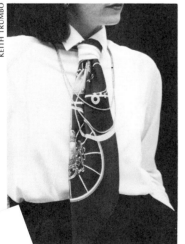

your scarf like a man's tie.

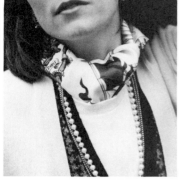

Tuck your scarf inside a shirt or T-shirt.

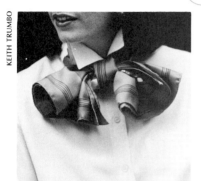

Bow-tie your scarf under your shirt collar.

short, wrapping it around twice, then bringing it in toward the throat and up and over into the opening of the knot. Pull short end until knot is at throat. Top with pearls or chains.

25. Scarf trick #6: side-knotted. Fold scarf in half diagonally. Toss over your shoulder so that the point lines up with your sleeve. Knot as shown.

26. Scarf trick #7: bow-tied. Accordian-pleat scarf several times along the width. Tie around throat in a loose square knot, fluffing out ends.

27. Scarf trick #8: tied and tucked. Fold scarf in half diagonally and wrap it around your throat with the point in back. In front, cross one end loosely over the other and tuck both inside your shirt or sweater.

28. Scarf trick #9: tied and trailing. Wrap your diagonally folded scarf around your neck, tying one end loosely over the other.

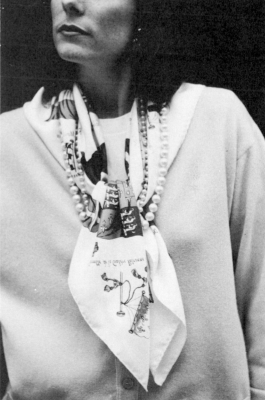

Yet another way to show off a scarf.

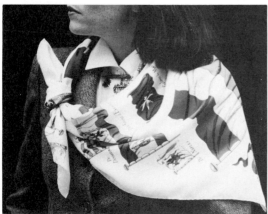

Toss your scarf over your shoulder and knot it at the side.

surprising ways to wear a
sweater: as a muffler, as a belt and
as a shawl.

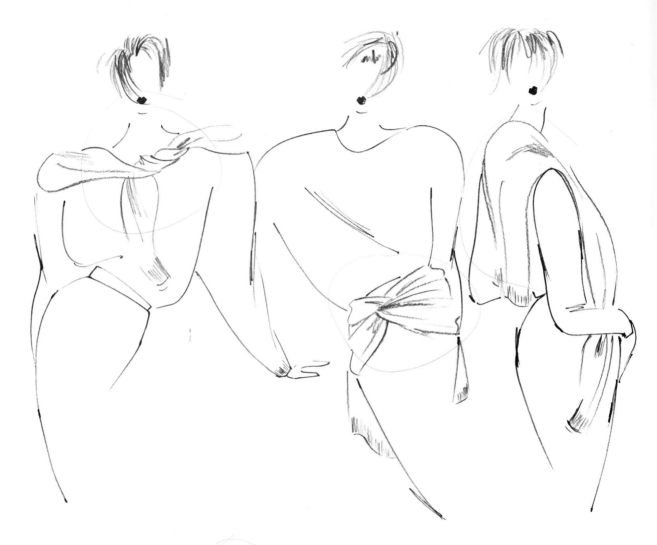

29. A new twist for an old sweater #1: wear it like a shawl.
Slide one or more sweaters over your shoulders, letting sleeves
dangle in front or twisting and tying them around your throat.
30. A new twist for an old sweater #2: wear it as a belt. Twist
sweater, knotting sleeves around your waist, then twisting ends
in.
31. Another new sweater twist: the sweater as a muffler. Tie
sleeves in front of your throat and let them dangle.

32. An add-on cowl/hood: the French call them *cagoules*, and slip them over T-shirts and sweaters to change the look fast.

33. Flowers—whether fresh or faux: pin a poppy at your throat, your shoulder, your lapel to feminize a shirt or suit.

34. A lacy hankie pinned on: when you have no breast pocket to tuck a pretty handkerchief into, pin one on with an antique brooch.

ROXANNE LOWIT

Pair a giant red poppy with a muffler to wake up an all-black look.

A flower pinned to your lapel can
add a feminine note.

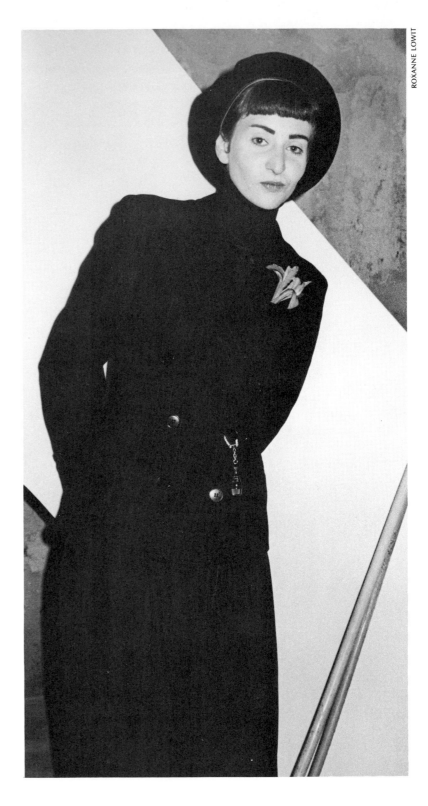

35. Pin up a skirt to show off petticoats: layer one long skirt over another, or over a lace-trimmed Victorian petticoat, gathering up the hem of the top skirt with an ornamented stickpin. It's a lovely summer look.

36. Pearls and pins: try a brooch at your neckline—or shoulder —coupled with several strands of long or short pearls or pearls and long gold chains.

37. A man's hat: this is a surprisingly feminine way to finish off a casual outfit.

38. Instead of bracelets, try two or more watches at the same time: on the same wrist, of course.

39. Anchor a shawl with an outsized brooch.

40. A backpack: trendy Parisians of all ages are substituting a backpack for a handbag. Wear it as you were meant to or sling it over one shoulder only.

41. A collection of pins: show them all off on a jacket lapel.

42. "Pair" different earrings: a sun on one ear, a moon on the other . . . or a square and a circle . . . an ornamented earring worn with a plain one . . . even a gold and silver.

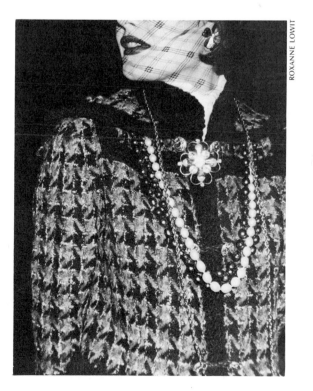

ROXANNE LOWIT

When accessories work together, like a seductive veil, a fabulous pin with pearls and chains, don't be afraid to pile them on.

43. Mix metals: combine gold and silver bracelets on the same wrists . . . gold and silver chains around your neck.

44. A pair of outlandishly large hoop earrings: without another piece of jewelry.

45. A giant shawl: fold it diagonally, then wear it over a long circle or pleated skirt and knot it on one side, at waist level.

46. A chignon net or a snood: wear a plain one during the day, an ornamented one for dressy evenings.

47. A shiny ribbon: tie a luxuriously thick one around your throat in a bow instead of a necklace.

48. A fringed muffler: wrap a lambswool or cashmere one around your head like a head band, fastening the ends with a fat knot and letting the fringe fall where it may.

Group a collection of antique cameo or marcasite brooches together and show them off.

Giant hoops can make a fashion statement.

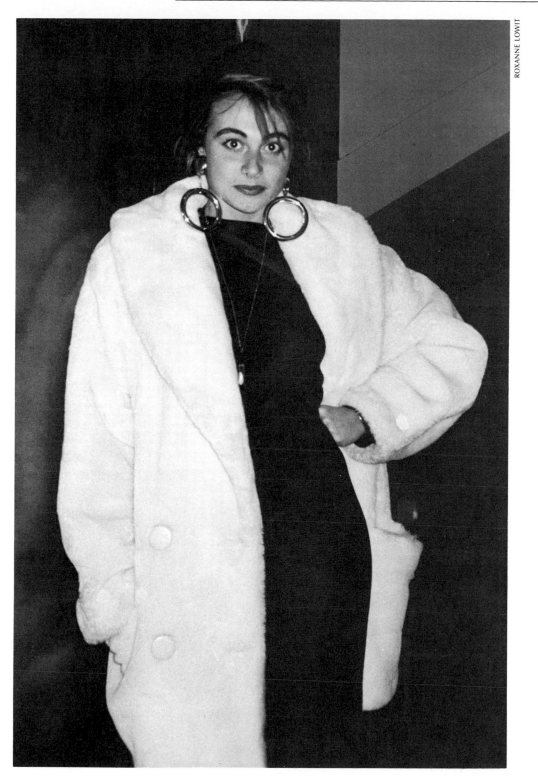

ROXANNE LOWIT

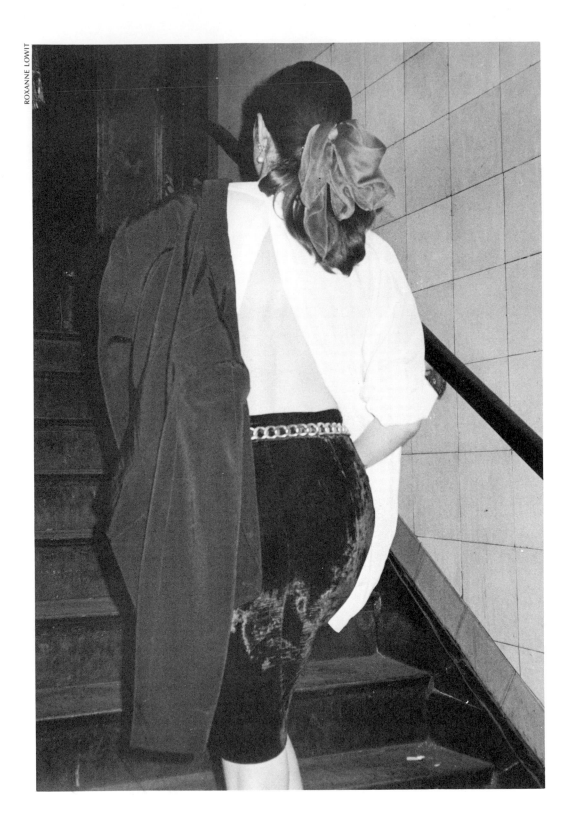

7

FLAUNT YOUR BEST FEATURES

NOT all Frenchwomen possess great faces and bodies, but they possess the power to make us think they do. One of the ways they go about it is by accentuating their positives so that their negatives pass virtually unnoticed. They flaunt their best features and in doing so, take attention off any less-than-perfect areas. After all, who would zero in on thick ankles or wide hips when bedazzled by a pair of doe-like, long-lashed, ice-blue eyes, or a fantastic décolletage? This is an approach that differs slightly, but significantly, from trying to hide what you don't like: rather than concentrating on playing down those features you are not fond of, you concentrate on playing up those you are. And it's a little French twist that is fundamental to the feelings of well-being most Frenchwomen share—a twist that could be yours, too.

This positive approach is learned early on: French mothers instill a physical confidence in their daughters that often has little to do with appearance. Beauty in France is a very individual matter; the French shun stereotypes and shy away from standards. French girls are taught instead to appreciate and to emphasize their most unique and striking, even offbeat, natural assets. Thanks to this parental attitude, they grow up feeling *"bien dans leur peau"*—"good in their skin" or comfortable with themselves. And it is this ease with her body, this confidence with her being, that gives the Frenchwoman the power to project attractiveness, no matter what she actually looks like.

One way to flaunt a fabulous back, a trim waist, a firm derriere, is with a floaty shirt slashed open behind, a snug skirt and a decorative belt as a focal point.

WHAT FRENCH MOTHERS TEACH THEIR DAUGHTERS

In France, beauty—and what forms it—begins at home. French mothers pass down to their daughters not only the idea of flaunting their best features, but, more fundamentally, the confidence to convince others that they are attractive, no matter what the sum of their physical parts. This guidance becomes part of a daughter's style, enabling her to present herself with *savoir faire* in all situations.

These are the legacies passed down from generation to generation that make up in part the mystique of French chic. They work for the French; they can for you, too:

* SELF-CONFIDENCE: High self-esteem allows the Frenchwoman to create illusions. She learns that by believing in herself, she can project whatever she wants about her looks. Her confidence is the result of a value system that prizes individuality. The result: she turns even an imperfection into a uniquely personal distinction. So, rather than lamenting the fact that she is not like everyone else, she revels in her differences.

* EASE WITH THEIR BODIES: Little French girls learn that "great" bodies come in all sizes and shapes. They learn, too, the Gallic *laissez-faire* attitude toward nudity, normal body functions and sexuality. This engenders a sense of ease, comfort and unself-consciousness that is evident in the way they think, in the way they move and in the way they care for themselves. They grow up following the example set by their mothers, aunts and grandmothers of smoothing and scenting their bodies before dressing—or undressing—to their best advantage.

* FEMININITY COMES FIRST: No matter how successful she might be in a man's world, the French female never forgets that she is a woman above all. And being a Frenchwoman involves an inherent sexuality, a femininity that is as apparent in her attire as in her attitude. She is always seductive and flirtatious, whether the subject is pleasure or business. And this feeling about herself starts early on. In Paris, even eleven-year-olds seem as stylishly self-possessed as adults. They have not only

mastered the art of accessorization at a very young age, but of coquetry as well.

* STANDING TALL: Part of the reason Frenchwomen look so long and lean—even when they are not—and clothing hangs so beautifully on them is because of their superb posture, which makes them appear taller than they actually are. They walk with head up, shoulders back, ribcage raised, stomach held in, and hips swaying slightly, yet naturally, from side to side.

* CLOTHES AS A SECOND SKIN: Frenchwomen are taught to view clothes as a second skin, to seduce with them in much the same way birds with their plumage do. Because this belief is so engrained, they almost instinctively turn toward those silhouettes, items and colors that express their individual personality and sexuality, and play up what they perceive to be their best features.

HOW TO EMPHASIZE YOUR ASSETS

What may seem like second nature to the French—the ability to so successfully flaunt their best features—really involves a body of knowledge that has become a part of their heritage. There is no reason, though, why you cannot teach yourself to have the same positive attitude.

STEP 1: MAXIMIZE YOUR ASSETS

Take a good long look in a full-length mirror. Decide what you like best about yourself and accentuate it by trying the fashion tricks listed below. Play up no more than two features. Pay no attention to flaws for the moment.

YOUR FACE: Focus on it:
* With an interesting brooch at your throat or high on your shoulder.
* With a sensational, attention-grabbing pair of earrings.

YOUR HAIR: Get it noticed:
* With a wonderful hair accessory that shows it off: a bow at the nape, a leopard headband, a tortoiseshell comb or barrette.
* With a hairstyle that really makes the most of it.

ROXANNE LOWIT

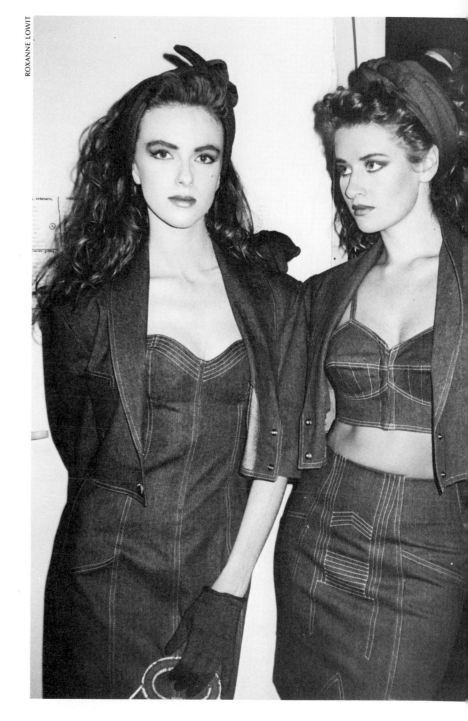

ROXANNE LOWIT

LEFT:
These second-skin clothes, designed by Chantal Thomass, leave little to the imagination and are definitely for the woman who feels good about herself.

RIGHT:
Two styles that dramatize décolletage no matter what size you are: a strapless sweetheart shape and fitted cropped bustier.

117

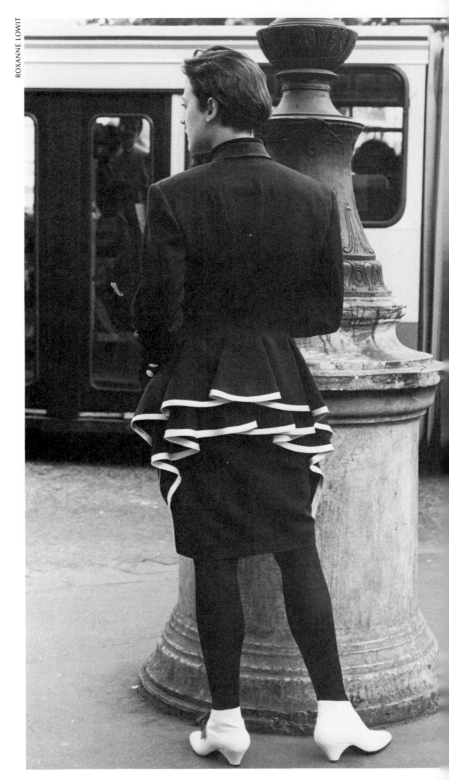

ROXANNE LOWIT

A shorter-back, longer-front,
ruffle-edge peplum jacket puts the
emphasis on the back.

118

YOUR NECK: Play it up:

* With a hairstyle that is elegantly upswept to emphasize its gracefulness and lengthen the line further.

* With a jewel-neck sweater accented with several short strands of pearls, gold or silver beads or an interesting necklace; an open-collared shirt worn with a tiny locket or diamond on a gold chain nestled in the hollow of the throat to catch the light.

YOUR BUST: Call attention to cleavage:

* With a lace bra or teddy peeking out of an unbuttoned soft silk shirt.

* With sweetheart necklines, off-the-shoulder and strapless tops.

YOUR WAIST: Stress its slimness:

* With wide belts or sashes . . . or an array of narrow belts worn together.

* With peplum jackets and all manner of clothes with nipped-in waistlines.

YOUR HIPS: Dress to display small hips:

* With stitched-down pleated skirts and slim, hip-hugging pants and straight skirts. Keep tops close to the body.

* With fanny-wrap sashes.

YOUR DERRIERE: Spotlight a spare, svelte derriere:

* With snug straight skirts and pants that feature back detailing: pockets, seams, contrast stitching.

* With styles that bring attention to the back: jackets cut long in front, short behind, a shirt slit open in back.

YOUR LEGS: Emphasize these lengthy assets:

* With short straight or swingy skirts.

* With a slender ankle bracelet.

YOUR HANDS: Keep them in the forefront:

* With one outstanding ring . . . or a wealth or little ones jumbled together.

* With bright enamel on well-groomed nails.

YOUR BACK: Keep it in focus:

* With a fabulous brooch ornamenting the back of a bare dress.

* With a V-neck sweater worn backward to keep attention where you want it.

STEP 2:
MINIMIZE
YOUR
FLAWS

Although the French expend most of their energy emphasizing what is special about their bodies, they never totally ignore what is not. To make the good look even better, they skillfully minimize problem parts in the following ways:

HIGH WAIST
Objective: to lengthen the torso:
with narrow belts worn low on the waist
with very narrow or nonexistent waistbands
with sweaters or shirts worn over skirts or slacks

LOW WAIST
Objective: to shorten the torso:
with wide belts and sashes
with longer hemlines
with wide waistbands on skirts and trousers

OVERSIZED BUST
Objective: to bring it into proportion:
with soft, loose shirts and sweaters
with V-necks and open collars
with easy-fitting slacks
with skirts with movement—
 stitched-down pleats, trumpet or A-line
with narrow belts and waistbands

SMALL BUST
Objective: to bring it into proportion:
with shoulder pads
with soft, silky blouses and fuller sweaters with layers

WIDE HIPS
Objective: to narrow them by widening upper body:
with shoulder pads
with shawls
with more voluminous tops, slimmer bottoms

SHORT LEGS
Objective: to make them appear longer:
with shoes with heels
with high-waisted skirts and trousers
with longer lengths
with vertical lines

STEP 3: PERFECT THROUGH PROPORTION

Proportion, one of the most important aspects of French dressing that Frenchwomen learn early on in their lives, is also one of the least acknowledged. Yet the relationship between line, texture, color and shape visually balances the body.

Proportion is as intrinsic to French chic as accessorizing and attitude. When clothing proportions are off, even the most perfect bodies will look unbalanced. Conversely, you can visually correct figure faults through the proportions of your clothes. Here are a few ways in which the French reproportion their bodies:

* ROOMY OVER NARROW—A big, bloused-out top over a skinny, close-fitting bottom, belted at the hip, slims and elongates the body. It perfects the silhouette by offsetting both an oversized and a small bust, by correcting both a short and a long waist, and by narrowing wide hips yet emphasizing narrow ones (depending upon the width and placement of the belt).

* SHOULDER PADS—These reshape the body into a V-form by extending the shoulders so that the waist and hips appear narrower. The size of the shoulder pads determine the proportion adjustment: the wider the shoulders, the smaller everything will appear in comparison.

* LONG OVER SHORT—A long jacket or sweater over a short skirt corrects the length of the torso, elongating short legs, and showing off long ones. A dark jacket over a light skirt plays down an oversized bust, while light over dark emphasizes a small bust and deemphasizes a wide bottom.

BE FINICKY ABOUT FIT

Fit is a subject about which the French are very particular. In order for clothing to flatter, it must hang, drape, wrap and, in general, conform to the body in very specific ways. We have already touched on this subject earlier, but it is important enough for a second look. Here is a short review of the French approach to fit that you can follow when trying on your garments:

* SLACKS/JEANS—Unless the style is deliberately over-sized and baggy, trousers should fit your curves snugly. This does not mean skintight, however; pleats should not appear to pull, and the cut should be long enough from waist to crotch to fit easily over the backside without looking as if it were binding.

* STRAIGHT SKIRTS—These are worn slim and close to fit smoothly over the stomach, hips and thighs without bunching or puckering. In order not to inhibit walking, they end in a slit or pleat.

* PLEATED SKIRTS—Those with stitched-down pleats tend to be the most figure flattering. Whether or not they are stitched down, however, pleats should fall cleanly. If they pull apart, the skirt appears too small.

* JACKETS—Jacket sleeves should end just below the wrist-bone, buttons should close without pulling and shoulders should be roomy enough for comfort.

* PULLOVER SWEATERS—Sweaters are never worn skintight, even when cut close to the body. There is always some room at the shoulders—to slip in shoulder pads, when needed—and across the bustline. Another favorite fit is the deliberately oversized sweater, often paired with very narrow bottoms.

HOW TO DETERMINE QUALITY

The French are sticklers for fine workmanship. No matter how high the price or how well a garment seems to look and fit, it still has to be well made. So before leaving the boutique with their choices, they always examine them inside and out to make sure these standards of quality are met:

TWELVE QUALITY DETERMINERS TO CHECK BEFORE BUYING

1. Fabric is of excellent grade.
2. Seams are stitched smoothly, with finished edges.
3. Buttons are functional and properly attached. On heavy fabrics, they should be sewn on a "neck" of thread, rather than flush to the fabric; on delicate fabrics, buttons are reinforced with a small swatch of fabric on the underside.
4. Buttonholes are well finished, without any loose threads. They are also large enough to allow the button to pass through without pulling.
5. Hems are invisible from the outside.
6. Zippers are dyed to match fabric and concealed in a placket.
7. Plaids and checks match in front and at seam lines.
8. Snaps are covered with fabric when visible.
9. Slits line up on both sides.
10. Sleeves are set in without puckering and fall straight from shoulder to wrist.
11. Linings are not visible at hems.
12. Collars fold back smoothly.

When the price is right and most of the important criteria are met, follow the practical French lead and increase the quality of a garment with minor alterations—change the buttons, redo a hem or reinforce the seams.

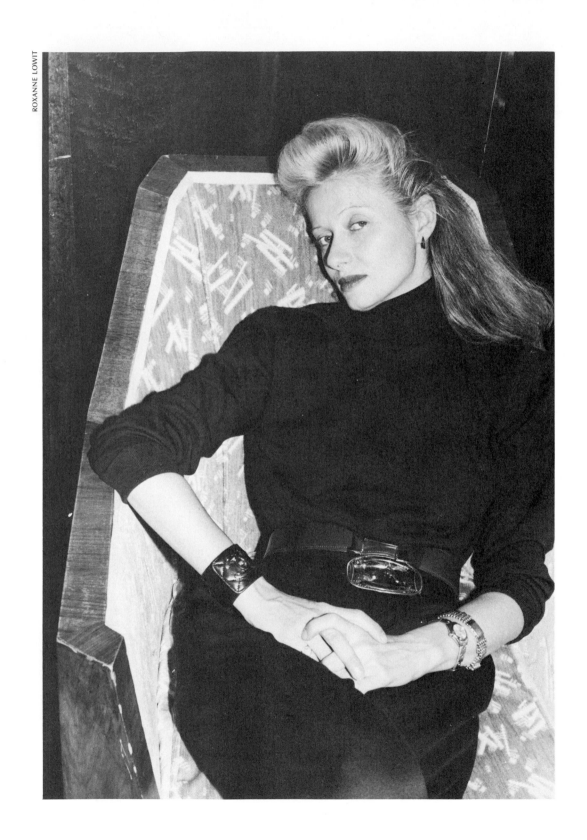

8

BUY ONLY WHAT YOU LOVE

THE dilemma of having lots of clothes but nothing to wear is not a typically French one, since the Frenchwoman usually shops selectively. In fact, her sole criterion is a *coup de coeur*: she buys only what she loves and what she feels beautiful in. The result is a wardrobe pared down to the most extraordinary essentials, purchased only for their quality, style, fit and beauty. Consequently, she happily wears the same items week after week, season after season, by mixing and matching them in a variety of innovative ways.

THE CONCEPT OF *COUP DE COEUR*

Designer Myrène de Prémonville in a simple black turtleneck and trousers personalized with an ornately buckled belt and bracelet.

Coup de coeur means to fall madly in love. It is that inexplicable and elemental attraction toward something—or someone—that dictates so many decisions in France. When shopping, it is a mixture of impulse and the absolute certainty that a particular item brings out your best and belongs in your closet. A *coup de coeur* can mean that it is worth spending more than you can afford on something sensational, but this is usually with the understanding that it will either save you money in the long run, or that it will make you so happy that you will not mind scrimping on other things. Sometimes a *coup de coeur* can mean sacrificing quality to cut, although this may seem to be a slight contradiction. But if it is a choice between a designer original black silk suit and a more up-to-date, off-the-rack one that simply *looks* better, a Frenchwoman will usually go for the style rather than the label —part of the mystique of chic is mixing the cheap with the costly.

FRENCH-WOMEN TELL HOW THEY SHOP

Shopping is a subject that is near and dear to a Frenchwoman's heart. Though every one of them goes about it differently, each looks for a *coup de coeur* when buying clothes and accessories. The rest depends upon individual whim, personality and needs. However, most Frenchwomen do their serious shopping at the beginning of each new season, when the stores have the largest selection, and then again during the giant sales that take place in January and June. They are also always on the lookout during the rest of the year for those little touches that individualize what they already own.

Let's take a closer look at the shopping habits of four fashion-conscious Frenchwomen, each with her own style and approach:

WHAT SHE DOES: "I usually buy complete outfits at the same time, since it never works for me when I buy individual pieces to go with what I already have. I tend not to buy a lot, but when I do buy something, I like to wear it for a least two or three seasons. I usually shop twice a year: at the beginning of autumn and the beginning of spring. Around Christmas, I buy a little something to add sparkle to my wardrobe: a dress or coat. I can't buy anything without having a *coup de coeur* for it."
—Michèle Grunberg, TV producer

WHAT YOU CAN DO: If you are so busy that you cannot take a tour of boutiques to find just the right color blouse to go with last year's suit, or do not feel confident enough to buy something and hope it works with the rest of your wardrobe, always buy a complete ensemble at the same time. If you shop in a boutique with a cross-section of labels, you can buy several alternates that may look terrific together, even though they are not from the same designer or manufacturer. For anyone who has not had much experience shopping, it makes sense to buy a few complete outfits. Once you feel more secure in your look and how to put it together, you can begin to branch out and experiment with adding individual pieces.

WHAT SHE DOES: "I buy clothes that I can transform because, today, chic is knowing how to mix things. I shop when the seasons change or when I feel like it . . . it's linked to my mood. But I don't really like to shop, except when I travel. Then it amuses me, and it allows me to make more interesting combinations. I want whatever I buy to last for years . . . but even so, I have to love it. I become attached to the clothes I feel express who I am." —Claude Degrese, marketing consultant

WHAT YOU CAN DO: If versatility is a must for you, buy pieces that you can combine and recombine for a number of different looks. Then keep your eyes open wherever you are for the intriguing piece that will add interest to your black skirt and sweater, for example. Shopping when you travel is a great way to put together a highly personal and special look, based on wonderful souvenirs.

WHAT SHE DOES: "Because my job is to know the trends, I often browse through shops, for business. But when I see something I like, I buy it in a few different colors . . . red, black and white. I buy on impulse. When I have a *coup de coeur* for something, I'm sure it's right. And quality is very important, especially for dresses and skirts, except in summer. I don't like summer clothes, so I buy inexpensive things that I can throw away."
 —Cyrile Pergay, creative director and psychologist

WHAT YOU CAN DO: Buying in multiples is a secret of many busy well-dressed women. You can save time and aggravation, and you are rewarded with an item in enough colors to work for just about every occasion. It also pays to invest the most money in clothes you will get lots of wear from. For example, if summer is an extremely short season in your area, as it is in Paris, follow Cyrile's lead and purchase inexpensive, throwaway pieces that will hold up for the season, but not much longer. Then pay a little more for your cold-weather mainstays.

WHAT SHE DOES: "I've always loved beautiful clothes and have tended to buy things that were expensive for the money I had. I don't plan what I need . . . and I don't have a budget. If I love something, I'll spend the price, but I won't buy just to buy. I always shop in the same neighborhood, in the same boutiques, and when I see something I like in a window, I go in to buy it,

although I don't like people to know where my clothes come from. I think it's important to buy items that go together. I actually buy very little, but want whatever it is to last ten years."

—Françoise Bouchard, psychiatrist

WHAT YOU CAN DO: Shop regularly at a store with a style you like if you are on a tight budget and cannot buy much at one time. Even though merchandise changes, each store usually has its own personality, so that the pieces you buy there at different times will often work together. A three-year-old skirt can appear fresh and new when paired with a sweater from the current season.

WHERE THEY SHOP

Thanks to the many magazines and newspaper features devoted to fashion, Frenchwomen usually have a good idea of prevailing trends and what can be found where before they even set foot in a store. They love window-shopping, and watch one another on the street closely for additional new ideas. Then, depending upon what they want to buy, they look in one or more of the following four places:

1. BOUTIQUES—These small specialty stores make shopping a novel experience. They usually concentrate on one type of fashion—i.e., trendy, sophisticated, classic, junior—and, to the uninitiated, seem to provide an intimidating amount of personal service. Frequently not all the merchandise is on display and you have to ask to see it. The French tend to be loyal to a few select boutiques, building up an ongoing relationship with a favorite salesperson. Don't let yourself feel out of place when shopping in a boutique; remember, the staff is there to help you. Browse around slowly, and if you like what you see, ask for assistance. Don't be shy about requesting advice. Most boutiques are geared to putting together total looks and showing their clientele how to adapt an outfit for different occasions.

2. DEPARTMENT STORES—French department stores are usually a collection of small boutiques strung together, and many American department stores use them as models. Consequently, you can find a number of different fashion outlooks under one roof. Even so, department stores can be a bit overwhelming. Here are a few hints to help make them fun:

* Don't try to do too much in one day. Get to know one or two stores well, before tackling any others.
* If you are looking for something in particular, save time and energy by asking for directions at the information desk.
* Browse through the designer areas to get a feel for and appreciation of quality. Then shop in the department that's in your budget range, seeking out clothes that have a more expensive look.
* Assemble all you want to try on in just one trip, since dressing rooms are often some distance from the merchandise.
* Work with a salesperson so he or she can assist you.
* Shop alone. Interestingly enough, the French may browse with friends, but when it comes to actually going out and buying something, they shop by themselves. Friends often lack objectivity, and unless you are very sure about your choices, you could end up buying what they like instead of what you do.

A word about sales. The French are mad for them, but they are careful not to purchase something just because it is on sale. This is a very important tip for everyone to follow. Buy something if you love it and you know you will wear it; buy something if you need it—but never buy something just because it's cheaper than it would have otherwise been; chances are you will rarely wear it.

Sales are excellent places to find both the trendiest and the most basic items. Here's where you can afford to experiment with a sequinned dress or brocade bustier, as well as stock up on T-shirts, classic pants and suits, sweater dresses, tailored blazers and other items.

3. SECONDHAND/THRIFT SHOPS—Resale shops are big business in Paris, and shoppers with a sharp eye and strong sense of style can unearth amazing treasures. A good thrift shop sells something for everyone. The secret to success is visiting them often, since most receive merchandise on a continuing basis.

Fabulous thrift shop finds include Hermès women's scarves and men's pocket squares; Chanel bags; beaded sweaters (wear them with jeans during the day); yards of pearls and chains; leather jackets; alligator belts and bags; great socks; reindeer and varsity sweaters; wide-shoulder jackets with pinched waists; floral silk blouses; silk kimonos and bedjackets; beautiful lingerie.

4. FLEA MARKETS—The gigantic Marché des Puces is the famous outdoor flea market of Paris. It contains hundreds of

booths, and is divided according to merchandise. And it can take days to go through. Whether the flea market you visit is large or small, look for: lace—jabots, collars, cuffs; antique whites—blouses, skirts, handkerchiefs; silk scarves, shawls, pocket squares, neckties, ribbons; shoes; jewelry; seamed silk stockings.

INVEST IN ONE. EXPENSIVE PIECE

One of the surest roads to chic is to always add at least one touch that costs a lot. No matter how inexpensive the rest of your outfit, this single item will upgrade the entire look. Not all French-women are rich enough to shop on the rue du Faubourg St.-Honoré, but they still manage to look as if they do.

Frenchwomen do not spend their money on unimportant items or on those that can be inexpensively duplicated. They splurge on one treasure that is classic, special and distinct.

WHERE THEY SPLURGE/ WHERE THEY SCRIMP	SPLURGE	SCRIMP
	—Hermès scarf	T-shirts
	—Handsome leather handbag	Black straight skirt
	—Leather shoes/boots	Canvas espadrilles
	—Real pony jacket	Pantyhose
	—Real gold chains	Pearls
	—Silk shirt	Cotton shirt
	—Important belt	Jeans/jeans jacket
	—Ray Ban sunglasses	Cotton or lambswool sweaters

This pair of hand-tooled cowboy boots are fashion perennials . . . and French favorites. And the more you wear them, the more beautifully worn and weathered they become.

ROXANNE LOWIT

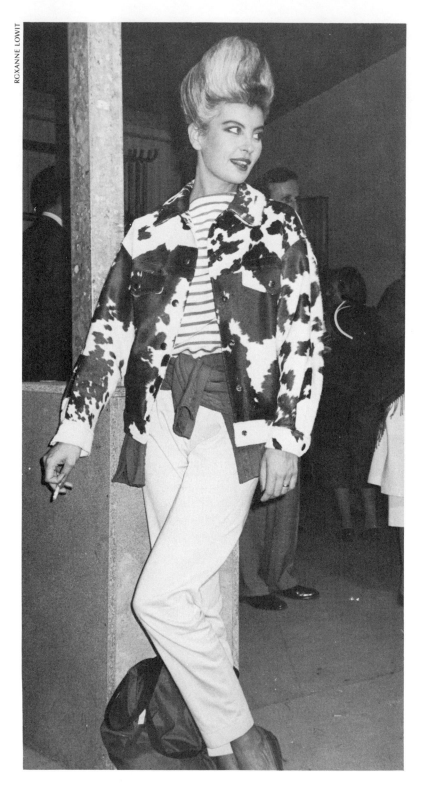

ROXANNE LOWIT

The ensemble looks trendy but not cheap, thanks to the throwaway chic—and high price tag—of the pony blouson, even though the rest of the elements were inexpensive. Change the pieces and the outfit could go to the office: picture the jacket worn with a black skirt and boots, an oversized pullover and a less radical hairdo.

HOW TO LEARN "CHIC"

Some women are born with it; others just look as if they were, but, happily, chic is a talent that you can teach yourself. Hubert de Givenchy explains it this way: "Chic begins by knowing yourself very well so that your personality comes through. Then, you have to be able to invent."

Frenchwomen appear to know themselves so well that their imaginations take flight naturally. Ask any woman applauded for her fantastic taste how she learned her style and she will probably tell you that staying chic is an ongoing process, involving one or more of the following approaches:

—Imitation. Find a role model—someone with sensational taste and a style that would become you—and copy it, from hairstyle on down. Then, as you feel more confident about your fashion choices, gradually put a little more of yourself into your look. Or as designer Agnès b says, "You can learn style by finding the balance between what you are, what you have always liked and what is new."

—Trial and error. Copy, experiment, play with fashion. Try things on. Pair them unexpectedly. Take risks with color or with the small touches that bring individuality into a look—jewelry, a shawl, pantyhose, belts. Sonia Rykiel, whose fluid, feminine style is immediately recognizable anywhere, thinks that no one can advise you, it is a matter of learning how to know yourself. "For years, you might have heard that red and yellow don't go together. Then one day you see that a certain red looks divine with a certain yellow. So, it's a question of your head. I'd rather that a woman make mistakes than wear a uniform that isn't flattering."

—Observation. Chic always involves the influences that affect you. Stroll down the streets and look at shop windows, architecture and those around you. Look at art in museums, galleries and books. And do not underestimate the lessons to be learned from the past. Designer Jacqueline Jacobson, whose label, Dorothée bis, is renowned for its kickiness and collectibility, believes that

looking at antique clothing in the flea market was one of the ways she herself learned style.

—Taking lessons. This does not necessarily mean formal classes, although you can take them if they are available. Rather, look at magazines, listen to the advice of salesgirls and stylists, and try to get informed on many levels by traveling and reading and by learning how to appreciate art and objects of the past. The value that the French put on tradition is for designer Vicky Tiel the essence of their style. "In France, there are a thousand years of art, history and beauty. There is an inherited culture. People with an inherited culture understand an old piece of furniture, and they don't redecorate. Just translate that furniture into a blouse. That blouse is still part of their wardrobe."

Whatever you do, don't get discouraged. Developing a sure sense of style takes time, but it will come. The French do not expect any woman to have mastered it fully until after she is thirty. A refined, highly personal style comes slowly, with knowing and feeling good about yourself. Chantal Thomass explains this very Gallic attitude: "Style is an apprenticeship that starts at adolescence, but comes with age and experience. When we're young, we try everything. Then, at a certain moment, we see what works."

CROSS-OVER CHIC: AN AMERICAN IN PARIS

Bien sûr, French chic is readily recognizable, yet the good news is that you don't have to be French to have it. You do, however, have to be confident enough to add your identity to whatever you put on, as certain style-smart Americans living in Paris have proved. They appear to have internalized the local fashion consciousness to such a degree that even when their labels read "Made in the U.S.A.," they still have the French look. Journalist Marion McElvoy is an acknowledged trend-setter and the first person everyone in Paris names when the subject is style. She is a master of the pivotal details and personal touches that transform the ordinary into the rare. She outlines her fashion philosophy:

"I feel that I have to be original. Now, *that's* a French attitude. While Americans tend to undersell their style, French

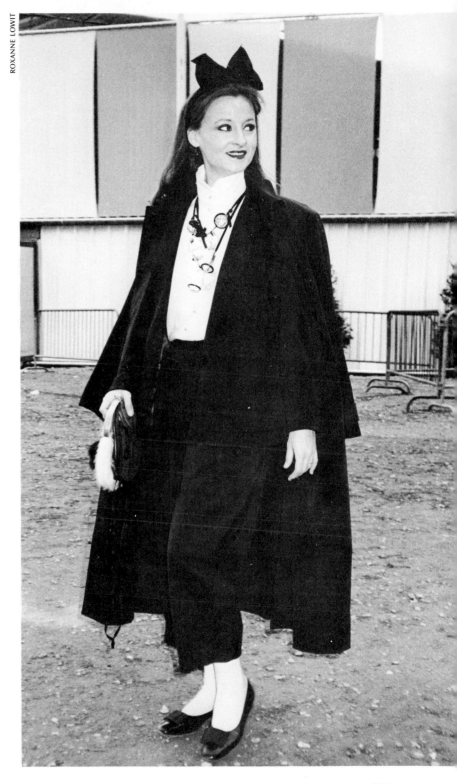

ROXANNE LOWIT

Marion McElvoy's amusing touches involve a wealth of artful accessories. She personalizes a dark pantsuit and coat with a big bow, eye-catching necklaces and a fur-trimmed handbag.

135

girls have an 'I don't care' quality, even though fashion is very important here. Because it's a tradition, it takes on an added importance.

"I might wear the same thing two or three times in a week, but in a completely different way. For me, it shows a lack of imagination to look the same all the time. This is something I think Americans can learn from the French: how to have fun with everything that goes around clothes—the jewelry, the shoes, the little details.

"I developed my style through trial and error. I used to be very theatrical, in the London vein, and I loved it. It taught me how to dare to do something. But I toned it down. Now, I would define my look as a clean romantic one. I could be wearing all black but then I add a romantic element. I always have to have an amusing/charming touch.

"I don't like shopping, and tend to wear things for years. I go through clothing periods. But when I get bored with clothes, I give them away—everything, except my old cardigans. I can't get rid of them. However, whatever I buy or own has to be quality, especially shoes and bags, which tend to be classic.

"I feel that if I don't look right, nothing seems to go right in the day, so I put some effort into dressing. I think that whatever you do, you shouldn't look like anyone else does."

A PARISIAN IN NEW YORK

Even when they have lived in America for ages, the French always manage to retain their special brand of chic. But environment influences the way they dress, nonetheless. Transplanted Parisian Maripol, a jewelry designer with a strong sense of fantasy who lives and works in Manhattan, explains how she's adapted her wardrobe to her surroundings:

"Living here has changed my ideas about fashion. I think I wanted to give a lesson to Americans, so I've become a little more outrageous. I did arrive, however, just as the punk look was exploding, and it really influenced me. Anyhow, I think it's going to take a long time before people accept my look. I belong to the past or the future, but not to this century. I like modern clothing, new materials . . . plastic dresses, things like that.

"My signatures are tube skirts, narrow pants and short tank tops . . . and always, lots and lots of accessories. I like clothes that show off my body. I was fatter when I was younger . . . I'm a fat person inside, but I watch out. I love to eat, so I exercise; I don't drink. I think I'm very strong because I like myself.

"I like to look sexy . . . in summer, the barer the better. I love black and wear a lot of it, although I didn't wear it much growing up, since it was principally for mourning. I was raised in dark blue and white. Now, it's black and very violent colors. I think of myself as a color person.

"Even though I have a lot of clothes, price is still an important consideration for me. I spend on shoes because I love them, but not on basics—sweaters, coats, raincoats. I guess it's my basic anticonservatism.

"I'm a compulsive buyer. I have tons of things that I like to cut up and change around. I get my clothes any way I can, usually from friends who have stores, or from designers. I also throw away a lot. But I keep my classics, my antique dresses and my

mother's clothes. My mother had fashions made for her and she had great taste. We're about the same size. So I wear her things, but not nessarily in the same way she did. For example, I wear her fur coat, but I wear it under a leather coat.

"I can adapt my look to any situation. It's always sexy and original, but it could be so straight tomorrow, if the occasion demanded. I'm seeing, however, that I don't have to change it. I can get the results I want, looking the way I want."

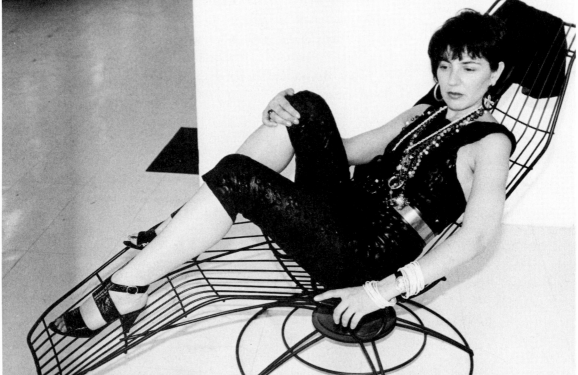

ROXANNE LOWIT

A Maripol favorite summer look resembles one she created early on for her rock-star friend Madonna: tight black Capri pants and matching tank top, a wide silver belt, high-heeled sandals and masses of jewelry jumbled together.

"Coco" Chanel in the look she made famous . . . one that appears as modern and up-to-the-minute now as it did in the thirties.

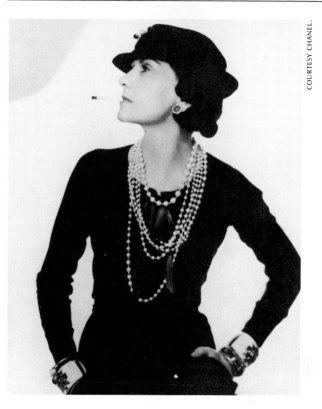

COURTESY CHANEL.

CHANEL: ONE LOOK EVERYONE LOVES

Although Frenchwomen are renowned for their fashion independence, there are certain styles they all adore. One look that they can't seem to get enough of has been around for years, and will probably continue to be for many years to come, perhaps because it embodies French chic at its best, perhaps because it works for every occasion. It was created by couturière Gabrielle Chanel sixty years ago. And even though Mademoiselle herself has been dead for some time, her "sure chic" style lives on.

An extraordinarily popular designer in the twenties and thirties, "Coco" Chanel so influenced fashion that her signature touches and adaptations of them look and feel as right now as they did then: masses of pearls and gold chains interspersed with stones; the chain belt, or two or three worn at once; a black bow tied in the hair; the slim suit with a braid- or color-piped cardigan jacket, of tweed, nubby wool or jersey; the little black dress; twin sweater set; black-tipped sling-back shoes; quilted handbag. These clothes are the stuff confidence is made of, because they fit in everywhere.

A part of the renewed Chanel popularity is certainly due to the times, but probably even more to the brilliant designer Karl Lagerfeld, who has the uncanny ability to re-create the renowned look. He updates old favorites so they more aptly express the sensibilities of the eighties woman. And he offers fresh options for wearing both old and new Chanel, especially to younger Frenchwomen, who are among the most avid collectors. It is not uncommon for some to spend their entire clothing budget on one pricy suit, reasoning that they will be sure of looking chic every time they wear it. Others buy pieces or look alikes they put together *à la* Chanel for a similar effect. Here are some of the ways you can wear both true and faux Chanel for the same effects:

—Try an old or new, but true, Chanel cardigan jacket with jeans, a wool or leather skirt or pants during the day and velvet at night.

—Wear a black sweater and skirt with Chanel touches, including a wide belt teamed with chain belts, cuff bracelets, sheer stockings, high-heeled black pumps, a chain-handled, quilted leather bag, pearl necklaces and earrings.

—Couple a simple cardigan suit with a strapless bra or bustier and chains galore.

—Purchase easy knit pieces with the Chanel feel: a cardigan jacket to wear over a T-shirt or pullover, ornamented with a chain necklace and gold earrings.

—Jazz up a sweater set with jewelry—pearls and chains, pearl button earrings—and finish with a bow-tied ribbon in the hair.

—Slip into a slim, black schoolgirl-style dress—with pearls, cuff bracelets on each wrist, a bow in the hair and a scarf tied around the chain handle of a quilted bag.

The Chanel jacket over a slim black skirt and black bra top.

ROXANNE LOWIT

9

TREAT HAIR
AND MAKEUP
AS FASHION
ACCESSORIES

American in Paris Marion McElvoy, looking more French than the French: sleek long pageboy tied with a bow, outlined eyes, bright red mouth—it all works together!

O N E of the things immediately noticeable on the streets of Paris is that hair and makeup are integral parts of the total look. They are treated exactly like accessories, so that they complement and complete whatever a woman is wearing—even change it from day into evening—while adding an amusing, highly personal note. To achieve this unity, the French choose their beauty accompaniments in much the same way they do their belts, brooches and bangles. They start with a basic outfit, then add the scarf, shoes, pin, hairdo and makeup that will give them the image they seek. The impact of a total look is most evident on the fashion runways when leading designers present their newest collections. Every ensemble is carefully coordinated with specially designed jewelry, shoes, scarves, hats, hairstyles and makeup.

The French beauty look, while highly individual, is generally natural and low key. Skin care receives the major emphasis. Frenchwomen like to appear as if they wear a minimum of makeup, so they use very little facial color. They favor a golden skin tone for a healthy look and neutral shades around their eyes. The mouth becomes the focal point of the face, often punctuated with a bright red lipstick. Hairstyles are generally simple and classic, but there is always a little French fillip—a charming roll or wave at the temple, a band, bow or barrette—that catches the eye . . . and sets the wearer apart.

Frenchwomen approach beauty as they do fashion. Rather than attempting to hide bad features, they down play them by playing up what they like best. For example, they will emphasize a pair of pouty lips by painting them a brilliant hue, call attention to a pretty neck with a low chignon covered by a pearl-studded snood, or accent almond-shaped eyes with smudged black kohl pencil. Whatever they do, they combine a sense of fantasy and humor with a need to innovate and even shock. "One night, the Frenchwoman might wrap a scarf around her head and play Isadora Duncan; another night, she might be classic. But she always plays the game that suits her," observes trend-setting hairstylist Jean-Louis David. "*Le jeu* [the game] is typically French. Both hair and makeup are part of it . . . a way for a woman to be discovered."

THE NATIONAL BEAUTY PRIORITY: SKIN CARE

The Frenchwoman learns how to care for her complexion at an early age. Like her mother before her, she puts herself in the hands of an "aesthetician" for a professional facial each month, and follows a daily home program designed expressly for her skin type, using her favorite products. Even though there are a multitude of famous-name French brands with wonderful reputations, the Frenchwoman never mixes them. And she deliberately keeps makeup to a minimum in order to allow her natural complexion to show through.

WHAT YOU CAN LEARN FROM AN AESTHETICIAN

The French call them aestheticians, those skin-care experts they rely on for their pampered complexions. Although the exact products and methods employed may differ among *instituts de beauté*, as skin-care salons are called, you can usually expect the same three-step method from the swankiest to the simplest of them:

STEP 1. An examination to analyze the skin.
STEP 2. A treatment based on the skin's specific needs, often employing herbal lotions or creams.
STEP 3. A makeup to show how to apply cosmetics correctly.

THE ANALYSIS

WHAT THEY DO: Examine your skin closely—usually under a giant magnifying glass—to categorize it. Your skin type determines the treatment program that follows.

WHAT YOU CAN DO: Analyze your own skin in much the same way, by examining it in a good magnifying mirror under natural light. Determine your skin type by matching your skin characteristics to those listed under each of the following four types. If you do not fit neatly into one category, select the one your skin most resembles, then make adjustments in your daily program. Be aware that your skin type will not remain constant. Weather certainly changes it: hot humid air encourages oil production, so skin feels oilier; cold dry air reduces moisture, so skin dries out. Age influences it as well: skin generally gets drier as you get older.

DRY SKIN
—pores are small or invisible.
—appears dull, may feel tight.
—prone to wrinkles or lines, especially around the eyes and mouth.
—occasionally itches, flakes, chaps.

145

NORMAL SKIN

—pores are visible but not obvious.

—appears clear, smooth and evenly textured.

—neither too dry nor too oily.

—not overly sensitive to climate or cosmetics.

OILY SKIN

—pores are enlarged and obvious.

—looks shiny, especially over the T-zone (the T-shaped area formed by the forehead, nose and chin).

—feels supple.

—may be prone to blackheads and blemishes.

COMBINATION SKIN

—looks shiny, feels oily in the center of the face (T-zone).

—dry on the sides, around the eyes, over the throat.

THE
TREATMENT

WHAT THEY DO: Once skin type is determined, the face is creamed to cleanse it thoroughly. A light massage might follow, to relax the shoulders, neck and face. After a fifteen-minute herbal steaming to open the pores and clear the complexion, you might be given a *gommage* or light peeling with an abrasive substance to whisk off dead, dulling cells on the skin's surface and/ or a hydrating or drying mask, depending upon skin type. After the mask is removed, eye and throat cream, as well as the appropriate moisturizer, are smoothed on. Before you leave, you are given written instructions for a daily home-care plan.

WHAT YOU CAN DO: Give yourself a monthly facial by duplicating several of the above steps. For example:

—Remove all your makeup with a cream cleanser, smoothing it on with gentle strokes in an upward, outward direction. Use circular motions always moving toward the inside of the eye. Tissue off gently.

—Steam your face for ten minutes, holding it at least eight inches above a pot of boiling water in which you have steeped herbs. Choose those that will give you the effects you want: fennel, nettle and linden will lift out impurities; rosemary will increase circulation; peppermint will stimulate; camomile will soothe. Tent a towel over your head to help capture the steam. (If your

skin is delicate or sensitive, skip steaming and move directly to masks.) Blot your face gently with a towel.

—Exfoliate your skin lightly with a commercial scrub or peeling mask . . . or make your own: rub almond or vegetable oil over your face. Pat on a scant amount of warm water, then a layer of fresh lemon or lime juice. Wait for two minutes but don't let mixture dry. Remove by rubbing the film with your index and middle fingers in a circular motion until a small ball of dead skin forms. Discard, and repeat the motion all over your face until your skin looks fresh and clean.

—Follow with a mask formulated for your skin type. Again you can make your own, as French experts often do, with ingredients you probably already have in either your refrigerator or medicine chest.

• FOR OILY SKIN: Mix brewers' yeast with buttermilk or yogurt and pat over your face. Lie down for ten minutes with eyes closed, covering your eyelids with thin slices of cucumber or cool, damp teabags (both of which are soothing). To remove: dampen a facecloth with tepid water and spread over your face, wiping off mask. Repeat as often as needed. Blot face lightly with a towel.

• FOR DRY SKIN: Mix an egg yolk with honey, and pat it over your face. Lie down for ten minutes with either slices of cucumber or cool, damp teabags over your eyelids, as above. To remove, dampen a face cloth with tepid water and spread over your face, wiping gently. Repeat. Blot face lightly with a towel.

• FOR NORMAL SKIN: Mix honey with a beaten egg white and a quarter of a teaspoon of cider vinegar. Apply and remove in the same manner as the dry skin mask.

• FOR COMBINATION SKIN: Treat dry and oily portions of your face accordingly.

—Finish with a sheer spread of moisturizer if skin is dry or normal; with astringent if skin is oily. All skin types: pat eye cream gently under eyes from outer corners to inner.

—On a daily basis: First and foremost, drink plenty of water; that's one of the best-kept French beauty secrets. Cleanse, tone and moisturize skin morning and night, using those products made for your skin type. (Even if their skin is oily, the French rarely use soap. In America, however, dermatologists acknowledge soap as the most efficacious cleanser.) While product selection is a matter of personal choice, here are a few guidelines to get you started:

ALL SKIN TYPES: Remove eye makeup with makeup remover and tissue.

DRY SKIN
—CLEANSE morning and night with a tissue-off or rinse-off cream or lotion and tepid water.
—TONE with an alcohol-free toner.
—MOISTURIZE while skin is slightly damp with a cream moisturizer.

NORMAL SKIN
—CLEANSE morning and night with a soapless liquid or super-fatted soap and tepid water.
—TONE with an alcohol-free toner.
—MOISTURIZE with a sheer lotion moisturizer.

OILY SKIN
—CLEANSE morning and night with a soapless liquid or a grainy soap (or alternate between them).
—TONE with an alcohol-based astringent or antiseptic lotion.
—MOISTURIZE under eyes only.

COMBINATION SKIN
—CLEANSE with a nondrying soapless cleanser.
—TONE T-zone with an alcohol-based astringent; drier outer areas with an alcohol-free toner.
—MOISTURIZE dry areas only.

THE FRENCH MIND-SET FOR MAKEUP

Though they learn about makeup basics from their aesthetician, Frenchwomen generally use cosmetics rather sparingly. They see good skin care as providing the beauty foundation, cosmetics, the chic. And while they opt for a more natural look than many of us on this continent are used to, they always include just the touch that is necessary to bring out their unique best. According to Tyen, Paris-based creative director of Christian Dior, there are several characteristics that set the French beauty look apart:

* Healthy-looking, slightly tanned skin.
* Little color on the face.
* Contrasting, rather than matching, eye, mouth and clothing colors.

* A red mouth.
* No contouring.
* Subtly defined eyes.

What does it take for *you* to create the French look? Knowing what you have going for you, plus the following essentials to tuck into your makeup case and use faithfully.

THE FIVE MAKEUP MUST-HAVES

1. BRONZING GEL OR TINTED MOISTURIZER for healthy radiance. Frenchwomen usually forego foundation and achieve the golden glow they love with a sheer bronzing gel or tinted moisturizing liquid. The skin underneath has, of course, been scrupulously cleansed and cared for to look its best.

Prime your skin for gel with a sheer sweep of moisturizer (omit this step when using a tinted moisturizer). This eliminates any "drag," and allows tint to be deposited evenly over the face. With your fingertips, using a little at a time, spread the color quickly over your face, from the center of the nose out over the cheeks, over the chin area and jaw line, then over the forehead. Blend edges with fingertips so that no demarcation lines are visible anywhere.

2. RED LIPSTICK to create a focal point. The French find the mouth very important; women of all ages love to accentuate it with red lipstick, even if they wear no other makeup. Then they play with balance. Usually, when the mouth is strong, eyes are subtle.

Outline your lips with a soft lip pencil in a tint close to that of your lipstick. Fill in with color directly from the tube, blending your liner inward with a lipbrush so you can't see it. Blot lightly with tissue.

3. POWDER IN A COMPACT, whether pressed or loose, for the gesture as much as the effect. Frenchwomen touch up their faces, even in public, using a lightweight, translucent powder in a lovely compact, in part because the gesture is so archetypically female. The compact itself can be a beautiful antique that they fill with loose powder, or it can be a pretty, pressed-powder-filled new one to tuck in a purse and draw out when the occasion warrants.

Using a clean puff, dab powder lightly over your nose and forehead, to dull the shine without masking the skin.

4. BLACK KOHL PENCIL for defining the eyes. French-women use this soft eyeliner pencil to line the inner rims of their upper and lower lids. This dramatizes their eyes, but the effect is subtle, since the eyelid itself is left either clean or shaded in barely-there neutrals.

With a sharpened black soft eye pencil (wipe point with a tissue after sharpening to remove any loose particles), line inner rim of your lower lashline by putting your index finger under your lashes, and gently pressing so the inner rim is exposed. Without exerting much pressure, slide the side of the point over the rim from inner corner to outer one. Line upper lash rim by opening eye wide, placing your finger along the lashline in the center of your eyelid, pulling up slightly to expose rim and lining it the same way you did with the lower lashline.

5. BLACK MASCARA for further emphasis. Use plenty, but apply carefully so that lashes look separate, never clumped together. A roll-on mascara is quickest to apply, but when they have the time, Frenchwomen use the cake kind, feeling it gives lusher results.

Begin by curling your lashes and powdering them lightly. Apply a coat of mascara, then separate lashes with a clean lash brush or comb. Apply two to three more coats, depending upon the effect desired, separating lashes in between each coat.

PRO POINTERS

When the subject is chic, rules are made to be broken, in beauty as well as fashion. Do as stylish Frenchwomen do: experiment to see what brings out your special qualities and what works with your personality and life-style. Keeping in mind everything we have already discussed, here are more pointers from Parisian pros that you might also want to consider:

* Try to create only one facial focal point: if your eyes are strong, play down your lips and vice versa.
* If bronzer provides too sheer a finish, or if you prefer a paler base, try a liquid foundation, but match it to the skin along your

jawline to prevent any line of demarcation. And make sure it's lightweight and transparent. A favorite trick of New York-based makeup expert Monique Mirouze to even out skin color is to add a little light moisturizer to foundation and then apply it with a damp silk sponge. Let it dry for a minute, then smooth over with a big powder brush to blend.

* If you have dark shadows under your eyes, choose a cream concealer in the same color as your foundation to cover, not lighten.

* For a better-than-natural mouth, select a lip shade close to the deepest tone of your lips.

* In place of eye shadow, try a drop of mineral oil or petroleum jelly on your upper eyelids . . . a trick expert Pierre Laroche has used on many of the world's best-known faces. Finish with several coats of mascara on your lashes.

* Line your lower lashline in soft color for a pretty change—in green, blue or violet.

* Powder your eyelids lightly to prevent shadow from streaking.

* Try navy mascara instead of black for a softer look.

MAKEUP FOR EVENING

The same woman who selects a natural look during the day might decide to go all out at night. Monique Mirouze explains that night light absorbs color, so you can go stronger, deeper, darker and more dramatic without looking over madeup. She offers these tips for evening glamour:

—Try a foundation a shade paler than your skin.

—Powder very, very lightly.

—Pencil your brows, since ends tend to disappear in evening light.

—Intensify your eye makeup: use more shadow, liner and mascara.

—Brighten your mouth in shades of apricot and orange. If you opt for red, choose a clear red, since blue-toned ones can look black at night, while brown-toned ones can look muddy.

NAIL
TIPS

Frenchwomen generally keep their nails short . . . and neat, polished with either a clear or deep-red enamel. When nails are red and they are in the mood for a change, they leave the moons unpolished. The result is very glamorous and feminine.

Although they don't really pay much attention to their hands, Frenchwomen do care for their feet; they have professional pedicures, year-round. These not only include nail grooming—toenails are clipped short and straight across, then usually polished red—but also overall attention to the removal of calluses and dead skin.

BEAUTY
TOOLS

Graceful gestures as well as proper application are key factors of French beauty . . . and the right applicator can accomplish both. Here are the motions and tools Frenchwomen use to achieve the results they are after. They:

* Shape a smile with a slender lip brush.
* Slide on foundation with a soft silk or synthetic sponge.
* Slim brows with pointed or slant-tip tweezers.
* Fluff on loose face powder with a fat brush, a velour puff or cotton ball.
* Smooth unruly hairs with a brow brush/comb.
* Separate lashes with a lash comb.
* Sweep shadow over eyelids with double-tipped sponge applicators.
* Sharpen pencils with a sharpener geared to each pencil's diameter.

HAIR CARE

Leading Parisian hairstylist Christophe Carita calls hair the "primordial accessory" . . . and it is certainly basic to the notion of French chic. As with every other accent she employs, the Frenchwoman adapts her coiffure to what she wears. Aside from a few classic hairstyles, like the few constant accessories to which she continually returns, she is usually willing to take a chance with the new and has very few preconceived notions about what works and what does not. Like long hair. The Frenchwoman does not equate her femininity with the length of her hair. For her, sex appeal starts in the mind and is projected through a total look.

HAIR IDEAS THAT TRANSLATE BEAUTI-FULLY, FROM TOP PARIS PROS

"Americans think that designers must give a recipe. But chic is all in the mix. Frenchwomen personalize their look by mixing . . . and this holds true for hairdos—a collection of looks. Seek out a look with a lot of possibilities that you can change with mousse, gel, ornaments . . ." —Jean-Louis David

"Hair should never be perfect. It should have an imperfect side, a subtle touch which amuses, which surprises . . . and makes it a little sexy. The Frenchwoman goes to the hairdresser because she wants to please others, to attract others. She wants a hairstyle that works with her personality . . . and length has less importance that *l'esprit,* or spirit. Parisians tend to be a mix. There's an equilibrium between "shock" and "classic" in hair and fashion." —Frederic of Mod's Hair

"Never follow fashion blindly. A woman should try to know herself . . . and her hair. And she should change her look from day to evening. By day, she should be fresh, natural. At night, she can be anything that she wants. But treat it like a game. Surprise is interesting . . . a woman should try not to always look the same." —Bruno of Bruno Dessange

153

COIF CLASSICS

There are certain classic coiffures that the French, traditionalists that they are, return to again and again. And whenever they do, they look fresh, new and timely. That's probably due as much to their changing a little something in the style to update it—the proportion, or the color, or the ornamentation—as to their timing. Frenchwomen return to them at the precise moment in fashion when these looks are the perfect complement to their clothes.

These are the five favorite hairstyles that have never stopped turning heads:

A little mousse, a few heated rollers or a curling iron are all it takes to transform a pageboy from straight to springy.

** THE PAGEBOY. You will find it in every conceivable length—from just below the ears, to the shoulders, both wavy and straight. What changes? The relationship between the length of the back and the sides. A favorite way to wear a pageboy now:

COURTESY CHRISTOPHE CARITA.

ABOVE LEFT:
Carita's "braided back" French twist.

ABOVE RIGHT:
The twist that ends in a tiny ponytail, from Christophe Carita.

chin-length, with the back somewhat shorter than the sides, bow-tied (with the bow at the side), or held back off the forehead with a headband.

** THE FRENCH TWIST. The ladylike French twist has long been a favorite of the chic set, to wear with a little designer suit by day, or a dressy extravaganza at night. It is fashioned by anchoring all back hair to one side with pins from your nape to your crown, then twisting the length over the pins in an upward direction and fastening it at the crown with a hairpin. Use bobby pins to hold the seam of the twist against your head. What changes? The way you wear your hair in front . . . and at the nape. Stylist Christophe Carita offers these two twists on a twist: a wavy top and ornamented back—an oversized velvet braid covering the twist—as well as front bangs and a low ponytail in the back.

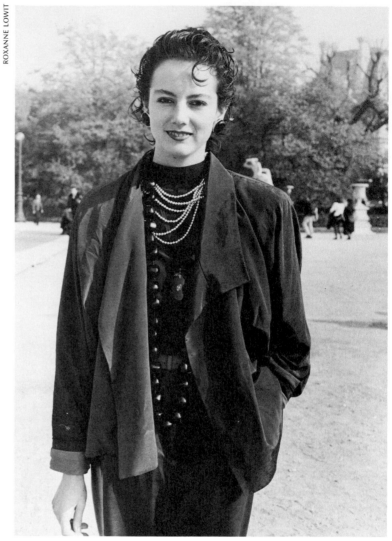

ROXANNE LOWIT

Gel gives this gamine look its shiny finish.

** THE GAMINE. This is the classic "little boy" or cropped cut, a variation of which actress Jean Seberg wore in the film *Breathless (A Bout de Souffle),* with Jean-Paul Belmondo. It can be short and smooth or short and spiky, falling on the forehead or brushed sleekly back. What changes? The texture of the hair, the amount of perfection or imperfection to the look, achieved not only through the cut but, these days, through the grooming product used. For instance, you can use mousse to achieve a ruffled look. Apply it to damp hair, rumple hair well, let dry; run your fingers through. Try gel for a smooth shiny look.

Apply a generous amount to damp hair, comb it through, combing all hair off the face but pulling a slender curl onto the forehead. Let dry. Do not recomb.

** THE PONYTAIL. You sometimes see a ponytail worn high on the crown, but most often low on the nape. Bangs frame the forehead, or all hair is swept loosely back, then sprayed lightly to stay in place. What changes? The way the ponytail is ornamented. French favorites now are a big fat bow, a silk flower, a thick strand of hair (or a braid of fake hair) wound over the elastic to hide it, or strips of jersey or fabric wound round and round, five times or more. You will often see a ponytail wound into a tight little knot or chignon for a change of pace.

** BANGS. Sometimes you see them, sometimes you don't . . . but they are usually there, simply styled back off the face. What changes? The length and thickness of the bangs. Favorite ways to wear them now are long—straight to the eyebrows, or brushed to the side and waved or curled. Short bangs look newest when sheared straight across the forehead.

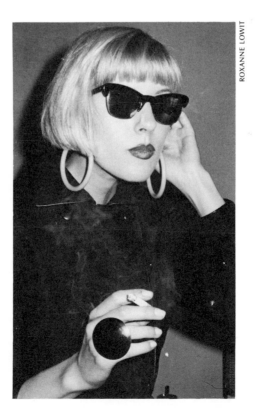

ROXANNE LOWIT

Two looks with the same cut: blunt-cut bangs are combed down onto the forehead . . .

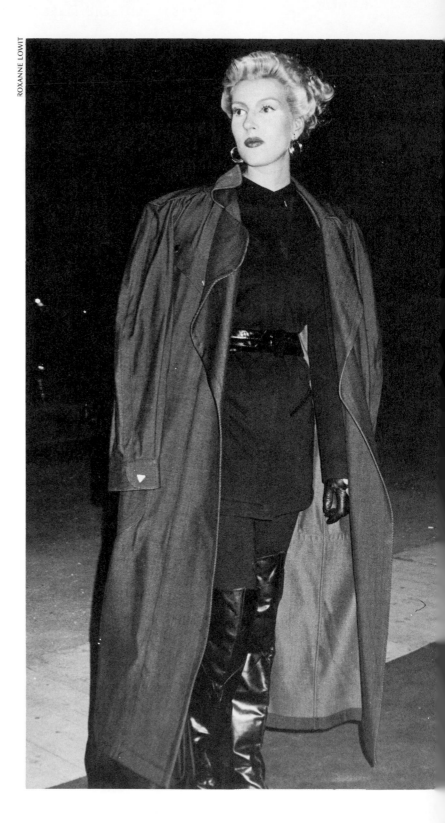

ROXANNE LOWIT

. . . or bangs are moussed and
waved back off the face.

LES REMEDES DES BONNES FEMMES

Frenchwomen often rely on what Bruno calls *"les remèdes des bonnes femmes,"* uncomplicated, natural hair-care remedies based on herbs and natural substances to keep their hair—as well as their skin—healthy. They usually consist of items you can easily find in your kitchen and are far less costly and often even more efficacious than ready-made products.

These are some of the most-often-turned-to treatments:

*** Lemon rinse to add light highlights to light brown or blond hair: Add the juice of three lemons to final rinse water.

*** Camomile rinse to brighten mousy hair: Boil several camomile tea bags in a pint of water. Allow to steep for a few hours, then remove. Use cool water as a final rinse.

*** Cider vinegar rinse for shine: Add ½ cup vinegar to final rinse. Bruno also recommends the following to clean hair in summer without drying it out: shampoo weekly and rinse daily with a mix of equal parts cider vinegar and cold water.

*** Rosemary rinse to add radiance to dark hair: Steep 2–3 tablespoons rosemary in a pint of boiling water for a few hours. Strain and use as a final rinse.

*** Hot olive oil conditioner to treat dry, damaged hair: Massage hair with hot oil, concentrating on brittle ends. Put on a plastic shower cap and wrap with a hot towel for twenty minutes. Wash with a very mild shampoo. Mayonnaise is a somewhat easier alternative to hot oil, since you don't have to heat it. Simply apply it to hair, comb through with a wide-tooth comb to distribute it evenly, leave on for twenty minutes, rinse and shampoo.

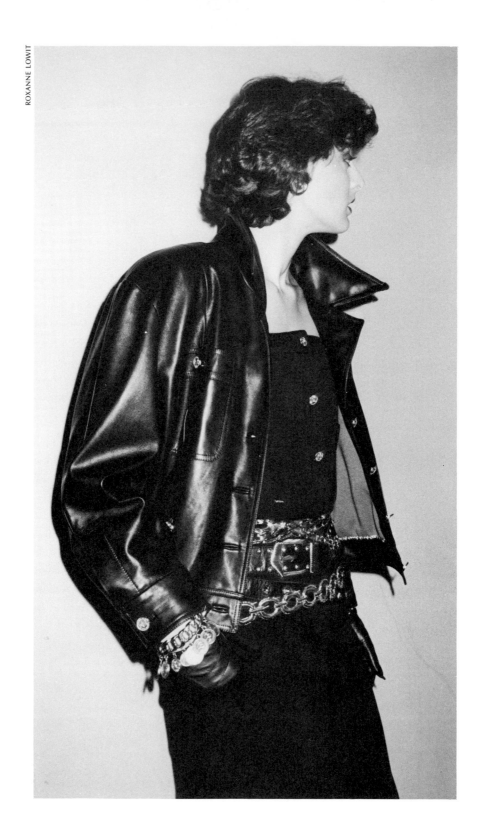

IO

DELIGHT IN
CONTRADICTIONS

A daring way to capture the chic of understated contradiction: a black leather baseball jacket that dresses down a black silk evening dress ornamented with chains.

SHE dresses true to type, yet may switch from Preppie by day to flirtatious Femme Fatale after five. She mostly sticks to neutral shades, yet savors the shock of a bolt of bright blue, a shot of chartreuse. At heart traditional, she would give her soul to make a head-turning entrance. The Frenchwoman obviously delights in contradictions, from the abstract—what to wear when—to the concrete—what to pair with what. And the oddly contradictory nature of her fashion style is actually the underlying force of her chic. A chic that is unexpected . . . amusing . . . charming. The Frenchwoman's bent to invent might just be the characteristic most responsible for that readily recognizable French look. Capture this contradictory spirit and you have the essence of French chic, no matter what you are wearing.

Although this spirit of contradiction is so simple to spot— you see it in the punch of a hot-pink hair bow with a basic black pullover and pants, the mix of a $5 T-shirt with a $500 leather skirt, the shock of a bikini worn with boots, or this season's St. Laurent slacks with great-grandmother's silk shirt, the unex-

pectedness of a buttoned-up blouse by day and a bare bustier at night—it can be elusive to imitate. You learned a little about this concept with accessories, but it really demands more attention because it is such a fitting summation to everything you've learned until now.

So take your cues from that inspirational Parisian ingenuity. Study its clever contrasts, and you will soon bypass being merely well-dressed to being French chic!

STUDIES IN CONTRAST

How do you add the unexpected without going overboard? Much of the secret has to do with logic, or illogic, if the French approach is any indication. Of course it is important to first train your eye to appreciate the tasteful as they do, then it is a good idea to experience putting together the essentials, accessorizing them in the most apropos-to-your-personality way. Once you have mastered these simple steps, you're ready to actually rethink French: to apply these tiny French twists that will make you look as good as they do.

• TAKE IT TO THE LIMIT... BUT NEVER GO TOO FAR

Although Frenchwomen have a wonderful sense of audaciousness, they always maintain a measure of the appropriate in their dress. They love to be noticed but never for the wrong reasons, such as looking excessive, ridiculous or out of place. So while they will gladly take their look to the limit, they know just how far they can go: there is a constant awareness of that fine line between what is original and what is outrageous.

Remember, as daringly as they may occasionally dress, the Frenchwomen's style remains fundamentally classic and understated. They let confidence rather than clothes carry their look.

This sense of sureness about themselves prompts them to try almost anything—and pull it off. Designer Ungaro sums it up this way: "When a woman is not sure, she should do more; when she is sure, she can do more."

Back in the U.S.A.: Cultivate this same confidence by practicing wardrobe flexibility: consciously and repeatedly add new and different elements to your look so that you become accustomed to change. Try not to accessorize any outfit the same way twice; try pairing different tops and bottoms; break up suits for fashion versatility; pile on the accessories if you usually wear few, or vice versa; add a beauty mark with kohl pencil high on your cheekbone . . . the list goes on. Leaf through the latest fashion magazines and pick a look you like but might never before have considered. Go to a store and try it on. You might be very surprised at the outcome.

The point is to take a few chances. You have already determined the basics of your style, so now use your imagination with the extras! The more you do, the surer you will become about the effects that will add chic to your look.

• MIX TO MATCH

Because they care more about interpreting fashion than following it to the letter, Frenchwomen deliberately veer from always wearing an item in the way it was intended. To them, a match occurs when the mix is pleasing. The charm is always in contrasts. So they will team the traditional with the trendy, the casual with

the formal, the antique with the new, to arrive at an allure that is quintessentially French.

Back in the U.S.A.: Take your cues from Paris—try not to be a prisoner of labels or price. Aim for a more eclectic attractiveness in one or more of the following ways:

—Labels: Unless you do not have any time to shop, or you have fallen head over heels with the look, try not to wear a total ensemble from one designer. It makes you risk looking like everyone else who owns the same things. Instead, mix items—a skirt from one, a shirt from another—and add interesting accessories to make them your own. Since a designer's style usually stays similar from year to year, you can also team items from different collections to liven up the look.

—Old and new: Integrate new items or ensembles into your wardrobe by pairing them with the older, the frayed, the tried-and-true pieces you already own. By doing so, you will wear them more irreverently . . . a quality the French find essential to chic. For starters, team a spanking new soft suede blazer with a second-hand silk shirt from the forties, and your favorite pleated pants. Add a fresh flower or an antique lace *pochette*. Sling a long strand of pearls around your waist . . . or a slim leather belt . . . even a man's tie.

—Casual and formal: Intermingle the dressy and sporty to arrive at a tongue-in-cheek chic that's frankly irresistible, like pearls with a sweatshirt . . . flats with formal wear . . . a khaki safari jacket with a T-shirt and an antique white lace skirt . . . a silk shirt with jodhpurs . . . a turtleneck with tuxedo pants.

—Daring and conservative: Keep everyone guessing by dressing classically during business hours, devilishly when the lights dim—a black lace bra under the partly buttoned jacket of a suit, for instance. Continually add touches that say one thing and mean another, like sexy lingerie under a severe business suit, or sassy sky-high heels with a staid knit skirt and sweater.

—Affordable and extravagant: Mixing cheap and costly is one area covered earlier, but its ability to add immeasurable cachet cannot be underestimated. Pile on ropes of real and faux pearls, real and faux gems; couple a designer silk scarf with a cotton T-shirt, a cotton bandanna with a pure silk sweater, a diving watch with a designer original, a cowboy belt with leather pants. Play with the idea, and you will be able to arrive at your own very special blend.

—Textures: Even when you dress in one color, opt for an interesting textural theme by mixing fabrics and finishes. This little trick will also make even the least costly outfit appear expensive. If one finish is shiny, select another that is matte. Team sleek and rough, smooth and rumpled. An interesting study in black: a black denim skirt, a silk shirt, a leather jacket; in white: twill trousers, T-shirt top, linen overshirt.

—Patterns: It takes a little bit of a knack and a lot of nerve to mix patterns harmoniously. A good starting point is with different sizes or reverse colors of the same patterns, like polka dots, which are stylish, fun . . . and so simple. Oversized dotted pants work with a small-dotted shirt and medium-dotted jacket, for example. Or white on black dots work with black on white dots. Ditto for stripes and checks and paisleys, all of which complement each other, too. Do you dare to wear a striped skirt with a dotted T-shirt and checked or paisley blazer?

• EXPECT THE UN- EXPECTED

An exciting unpredictability accounts for that intriguing aura of mystery about French style. Frenchwomen love to surprise . . . to take poetic license with their look. The only thing you can bet on is that they probably will not be dressed exactly as would be expected in any given situation. Initially, you might not notice anything unusual about the way they put themselves together, but look closely and there is usually a teeny twist on the traditional that makes all the difference.

Back in the U.S.A.: Keeping in mind all you have learned thus far, why not rethink what you would usually wear to that gala next week. Chances are, it needs a whimsical touch . . . a tiara? Too far out? How about dressing down instead of up? A tuxedo instead of a gown . . . a curvy short dress instead of a long skirt?

Give how you go about it some thought, but do not go entirely against the grain. You do not want to feel in costume, just that you are playing up another facet of your personality, one that you might have kept hidden until now.

Add charisma to every occasion with a little contrast. Instead of wearing what might be expected in the following situations, keep them guessing!

THE SITUATION	THE EXPECTED	THE UNEXPECTED
1. Exclusive restaurant	Tailored dark silk dress (you want to look rich)	Short little black dress—with no back (you'll not only look rich, but gutsy, as well)
2. New Year's Eve	Silk pants and top (you want to be comfortable . . . it's a long night)	A sexy, slinky party dress with a pair of sensational flats (sex appeal plus comfort)
3. Business meeting	Pin-striped gray suit, a shirt and floppy bow tie (dress-for-success look)	Pin-striped, double-breasted coatdress with a flower on the lapel (assured enough to never let them forget you're a woman)
4. Dinner party at home	Jeans and a pullover (relaxed and casual)	Jeans, *oui*, but in black leather (sensuously relaxed)
5. Job interview	A strict suit (it's a corporate classic)	The soft suit or dress with jacket (smart prospects psych out the look of the field and dress accordingly)
6. Blind date	A short snug knit ensemble that clearly outlines your assets (you've got it, so flaunt it)	A body-conscious but not blatant dress that bares arms and shows some leg (suggest rather than state)
7. Meet his parents	A new outfit with matching shoes and bag (you want to make a good impression)	Your favorite cashmere sweater with a skirt, pearls, a chain belt (clothes you feel comfortable in will give you confidence)
8. Sunday brunch	Sweatshirt, jeans, sneakers (it's the weekend . . . who's going to notice)	Jeans with a silk shirt, cardigan sweater, ascot, socks and loafers (you never know who you're going to run into on a Sunday)
9. Cocktail party	A short, sexy black dress that shows plenty of cleavage	Soft white silk trousers, a white silk shirt, with top buttons open, a flower at the waist (you'll stand out in white, since everyone will be in black, plus look curvy and feminine)

• OPPOSITES ATTRACT

Even in boyish attire, the Frenchwoman loves being a girl, adding those touches that are constant reminders of her femininity. She will soften the severity of a man-tailored suit with a silky shirt, a chiffon scarf, a length of lace trailing from a pocket, sheer black stockings and high heels, extravagant earrings, a curly, bow-tied coiffure and bright mouth . . . any touch of whimsy to remind her audience that she is playfully bending gender. Part of the game, too, is letting her disposition carry her dress. Reminders of this sort involve pouting her lips when she speaks to a man, so she looks like she's ready to be kissed, or looking him intently and admiringly in the eyes when he speaks, when she speaks, making him feel charming, sexy and oh so witty. Her actions are so engrained that they are totally unselfconscious.

Back in the U.S.A.: You're never too old to play the game. Start with your dress and chances are your disposition will follow. Moderate a really man-tailored look with a feminine hairdo, interesting gloves, eye-catching rings or red nail enamel. A pastel palette or a sensuous scent also add memorable feminine notes.

LOOKS TO THE CONTRARY

You will notice in the following photos that any one woman can harbor many contradictions. She may dress up one day, down the next, wear all or nothing, be boyish or vampish at whim. Her look never stays static, which only adds to her interest!

Played-down to all-out—Princess Caroline of Monaco is a celebrated case of that fabulous French fickleness. She is loyal only to looking great! One morning she is dressed down at Dior . . . accenting a severe tweed suit with a simple pair of earrings and a chain necklace. The next afternoon, she pays *hommage* to Chanel, loaded down with a wealth of chains, pearls and double C's, as well as Coco's famous signature side hairbow.

ROXANNE LOWIT

Princess Caroline—
demure at
Dior.

ROXANNE LOWIT

Princess Caroline—
all decked out
at Chanel.

Old-guard to outrageous—Guarded at lunch, avant-garde *après,* that is the way Paloma Picasso plays the fashion game. Her little afternoon suit could not be purer—or simpler—while her cocktail garb is at the opposite end of the spectrum. If you want to get noticed, wear a dramatic hat and sunglasses after dark.

Paloma Picasso—"old guard" day garb.

ROXANNE LOWIT

Paloma Picasso—avant-garde
evening attire.

Little boy to "What a girl!"—The touches that contradict masculine attire: a soft pastel shawl and a voluptuous red mouth. Then vamp up an evening outfit with chains, long gloves and glimpses of skin usually kept under wraps.

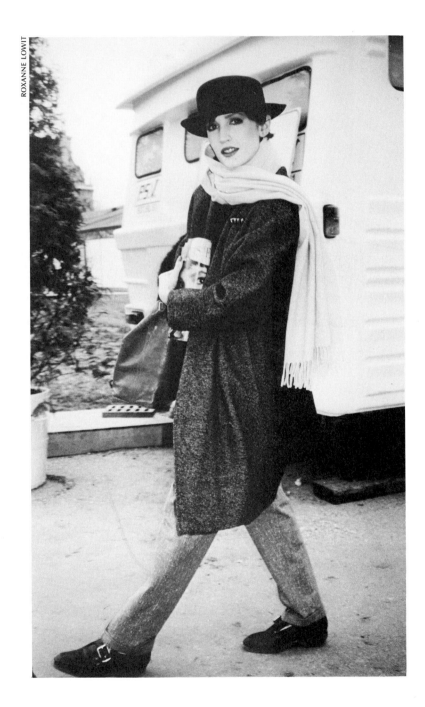

ROXANNE LOWIT

By day—the clothes from his closet.

172

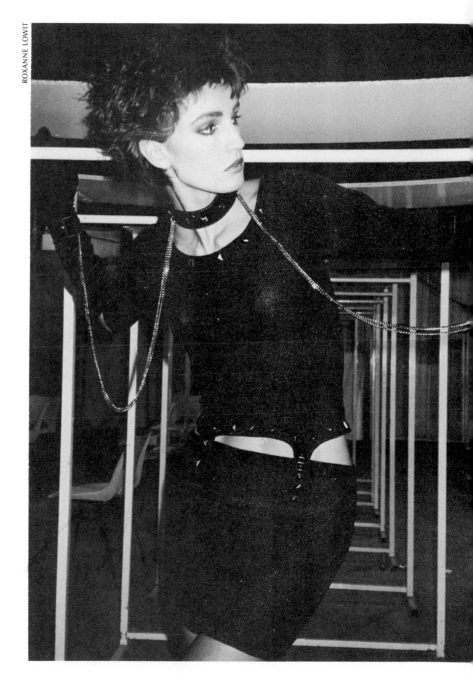

ROXANNE LOWIT

After dark—vamp it up.

DETAILS THAT MAKE THE DIFFERENCE

French chic is characterized first by the special detail that gives a fresh new appeal to a total turnout, and second, in the way that detail is used. To get you started, try these few new ways to work some of the same old things into your wardrobe:

The Detail: LEGGINGS. You can always top them with a big shirt or oversized sweater. No surprises there.

The Difference: Create a layered look by wearing leggings under a skirt; under rolled-up jeans or cropped pants; under a crinoline but over lace pantyhose for a romantic evening look.

The Detail: BLACK LEATHER BUSTIER. It livens up a staid suit and simply oozes sex appeal.

The Difference: Try it under a sheer organza or lace blouse . . . under a black silk shirt, unbuttoned and knotted at the waist. For more of a difference: Pair it with a short black leather or a long flounced black lace or velvet skirt to create a strapless evening "dress."

The Detail: ELBOW-LENGTH BLACK GLOVES. The perfect finish for a bare black evening dress.

The Difference: Pile your jewelry over them, including an oversized ring on your pinky. Wear your gloves during the day under a long-sleeved black top with a watch at the wrist (over glove and sleeve), or over the sleeve and bunched down at the wrist.

The Detail: SHOE CLIPS IN A VIBRANT COLOR. Choose a pair of oversized pompons or poppies and clip them on to plain pumps or ballerina flats.

The Difference: Clip one on to a lapel, a neckline (at the throat of a buttoned-up shirt); over a ponytail; on a wide ribbon to tie around your waist or wrist.

The Detail: LONG WHITE ANTIQUE PETTI-COAT. This is wonderfully romantic slipped under a denim, gauze or print skirt, with just a little lace showing.

The Difference: Try it on its own, teamed with a man's white T-shirt, an oversized white cotton shirt, belted at the waist or

hip, a cashmere pullover, or an oversized V-neck with ropes of pearls.

The Detail: OBLONG ANIMAL PRINT CHIFFON SCARF. Throw it over your shoulder, letting the ends float, or tie it around your throat.

The Difference: Tie it around your waist and fasten with a big brooch; bow-tie it in your hair, fanning the folds out so it really shows; wrap it around your chest as a bandeau or halter top.

The Detail: SWEATER VEST. Team it with a T-shirt or blouse, slipped under a jacket or cardigan.

The Difference: Dress it up by wearing it on its own, paired with a long silk or velvet skirt or flowing pants in a matching shade. Ornament with strands of gem-studded chains or a chatelaine at your waist.

CONCLUSION

THAT FAMOUS, FABULOUS FRENCH CHIC

F R E N C H chic—striking, subtle, sexy, surprising, understated and overdone, witty, one-of-a-kind—is certainly elusive. Yet, although it is composed of a variety of styles, there is only a single spirit—self-expression. The French dress to express their personality, with a flair that they seem to achieve with less effort than anyone else. However, you now know that thought and planning are a part of French chic, and that means you can have it, too.

How did the French get so lucky? The very stylishness of their culture as a whole is believed to be one major influence upon their fabulous fashion flair. Paris itself, because of its beauty and sense of architectural balance, proportion and scale, is pointed to by many as another inspiration and catalyst. Being surrounded by such perfection every day might have automatically trained French eyes from infancy on, giving them a head start on chic. After all, Paris gave chic to the world. Western fashion began there hundreds of years ago, and it not only re-

mains a pleasure, but big business as well. Unlike other cultures or countries, which might find fashion style a frivolous, for-women-only subject, the French—men and women, old and young—find it a serious topic of conversation.

Changeable as it seems, the principles of taste behind French chic usually remain remarkably constant, as you can see in the following definitions of French chic from five designers, all of whom have very different styles:

"French chic is knowing how to add that one little touch that makes all the difference." —Emmanuelle Khanh

"It's a mix of nerve, wit and fashion culture."
 —Thierry Mugler

"French chic involves few items, a lot of fantasy in putting them together and a talent with accessories." —Azzedine Alaïa

"It is a little disharmony, an element of risk in fashion."
 —Popy Moreni

"It's a straight skirt, turtleneck sweater and pearls . . . something simple and stylish. French chic involves a sense of clothes, of movement—fashion that doesn't look it."
 —Michel Klein

By understanding and fulfilling the individual needs of their customers, designers actually help Frenchwomen develop the fashion sense and confidence they need to achieve true chic, while always reinforcing the French notion of style. French fashion publications are also influential in spreading the word. Although they tend to take a less "how-to" approach than American magazines, French editors put looks together in highly inventive and creative ways, so that their readers are inspired to try the same things by just looking at the photographs.

It is easy to see that France and fashion are inexorably linked—historically, commercially, psychologically—so much so that it is difficult to remember that style is not always a trait with which one is born. Frenchwomen had to learn it, and you can, too. It's never too late to start.

ABOUT THE AUTHOR

Top fashion journalist SUSAN SOMMERS has conceived, written and produced stories for the *Daily News Magazine, Cosmopolitan, Ladies' Home Journal,* and *Family Circle.* She has been editor of *Cosmopolitan*'s *Beauty Guide,* beauty editor and Paris correspondent for *L'Officiel/USA,* and creative director of Orlane Cosmetics. She also produced the first American issue of the French monthly, *Votre Beauté,* and is the author of *Beauty After 40: How to Put Time on Your Side* and *How to Be Cellulite Free Forever.* Susan Sommers currently creates beauty and fashion articles for leading publications and promotional copy for a variety of clients. She lives in New York City.